Kicking Butt in Computer Science:
Women in Computing at
Carnegie Mellon University

by
Carol Frieze, Ph.D. and Jeria Quesenberry, Ph.D.

First published by Dog Ear Publishing
4011 Vincennes Rd
Indianapolis, IN 46268
www.dogearpublishing.net

ISBN: 978-1-4575-3927-5

This book is printed on acid-free paper.

Printed in the United States of America

Table of Contents

Acknowledgements

The authors wish to express our gratitude to those who helped make this book possible. We thank Carnegie Mellon University and the School of Computer Science (SCS) for their institutional support and the value they place on inclusion and diversity. We also acknowledge the dedication of former and current deans of the School of Computer Science, Raj Reddy, James Morris, Randy Bryant, and Andrew Moore. We appreciate the contributions of our fabulous faculty and staff, and in particular, Lenore Blum whose expertise in gender equity was instrumental in establishing a foundation for change. We also thank the many students who participated in the case studies and shared rich information about their experiences and perceptions. We give additional thanks to our graduate students who continue to be indispensable as leaders, role models and mentors. Finally, we would like to give a special thanks to the truly outstanding students of *Women@SCS*, and more recently SCS4*ALL*, who invest their time, energy and talents towards building a community in which both men and women can be successful in computer science.

We dedicate this book to all those women kicking butt in computer science.

CHAPTER 1

Introduction

If we're going to out-innovate and out-educate the rest of the world, we've got to open doors for everyone. We need all hands on deck, and that means clearing hurdles for women and girls as they navigate careers in science, technology, engineering, and math.

– First Lady Michelle Obama, September 26, 2011

Are women kicking butt in computer science? Consider these statistics...

56% of 2013 Advanced Placement test-takers in the United States were female. Yet, only 19% of the Advanced Placement computer science test-takers were female.[1]

57% of 2012 undergraduate degrees in the United States went to women. Yet, according to National Science Foundation (NSF) and Taulbee reports respectively, only 18%[2] and 14%[3] of computer science undergraduate degree recipients were female; a huge decline since their peak of 37% in 1984.

57% of 2013 professional occupations in the United States are held by women. Yet, women hold only 26% of computing occupations.[4]

This persistent under representation of women in computing has gained the attention of parents, employers, educators, and researchers for many years. Yet, it is clear that the participation of women in computing has shown little progress in spite of numerous studies, reports and recommendations on the topic. Some might say the reasons for the situation remain a mystery.

At Carnegie Mellon University we do not believe that the situation is either so mysterious or such an intractable problem.

Women are kicking butt in computer science in some environments. The percentage of women enrolling and graduating in computer science (CS) at Carnegie Mellon has exceeded national averages for many years. Indeed, the school hit the news in fall 2014 when an unprecedented 40+% new women entered the CS major.[5] But Carnegie Mellon is not alone—some

...ions have also had success in addressing the gender gap. , Mudd College, for example, has gone from 10% women in CS in ...006, the year Maria Klawe took over as college president, to 40% women in CS by 2012. A few other schools, while not always hitting the headlines like Harvey Mudd and Carnegie Mellon, are joining the list of schools who are investing in cultural change. While schools like Harvey Mudd and Carnegie Mellon may be quite different, and have different approaches, they share some straightforward practices that have proven to be successful: they pay attention to the situation, they assess which interventions will work in their particular environments, they have institutional and financial support, and they have multiple-levels of commitment. They are living proof that—as Carnegie Mellon CS professor Lenore Blum says—"it's not rocket science!"

This book seeks to answer the question "how have schools like Carnegie Mellon been so successful?" especially when the participation of women in CS nationwide has remained dismally low.

Here we focus on the Carnegie Mellon story as an example of one approach that works well for sustaining and graduating a community of women in computing with persistence rates practically identical to their male peers. We offer a positive perspective on the topic and some specific explanations aimed at demystifying the overall dilemma.[6] The work at Harvey Mudd, discussed more fully in the Association for Computing Machinery (ACM) *Inroads* article (Alvarado et al., 2012), stands as another example and story of success. While the stories may be different both offer useful strategies and recommendations for increasing diversity in computing.

Since 2000 we have learned many valuable lessons about women in CS at Carnegie Mellon. In a nutshell, what stood out to us are the following: for women to be successful in CS we *needed* to change the culture and environment, *but*, we did *not need* to change the curriculum to be "pink" in any way. Indeed, gender difference approaches have not provided satisfactory explanations for the low participation of women in CS and beliefs in a gender divide may actually be deterring women from seeing themselves in male dominated fields.

We hope the Carnegie Mellon story can help debunk the perception that there is an attitudinal dichotomy towards CS based on gender. Indeed, we illustrate how undergraduate students in the CS environment at Carnegie Mellon show a spectrum of attitudes towards the field rather

than a gender divide. We also hope that this example can help draw attention to what we believe is a much bigger issue: the perpetuation of cultural beliefs that boys and girls have different intellectual "gifts" based on gender and are therefore suited to different fields of study and different careers. We believe this way of thinking represents a major roadblock to increasing the participation of women in CS. The Carnegie Mellon story is one example of how a focus on culture and environment can help bring about change for the benefit of a community of students, a university, and even a city in the midst of reinventing itself.

Revealing the Women-CS Fit at Carnegie Mellon University

In the fall of 1999, Carnegie Mellon saw a striking increase in the percentage of women entering the CS major. Lenore Blum joined the faculty of Carnegie Mellon University's School of Computer Science (SCS) that same year. Blum, a world-renowned CS professor and a long-time advocate for women in math and science, was called on to ensure that the overall experience of the new and dramatically increased numbers of undergraduate female CS students would be positive for the women and for the school as a whole. Working with graduate students who had already started connecting women across all departments in the School of Computer Science, they formed *Women@SCS* an organization of faculty and students (mostly, but not all, women) led by a Student Advisory Committee. In 2000, Carol Frieze was invited to join forces with *Women@SCS* eventually serving as the organization's director. Since that time, she has coordinated the efforts and mission of the organization. In 2007, Jeria Quesenberry began a partnership with Carol to investigate the role and value of *Women@SCS* and to look at the overall picture of women in computing at Carnegie Mellon. The historical account of our individual and collective paths has led us to the development of this book.

Carol had a background in gender and cultural studies but knew little about CS and its community, although, like many people, she was familiar with the geek stereotypes of popular culture. From 2000 onwards she read everything she could get her hands on relating to women and CS. Indeed, the growing number of studies was rapidly turning "women and computing" into a field of its own. Of particular relevance was the book *Unlocking the Clubhouse* (2002) by Jane Margolis and Allan Fisher, which focused specifically on undergraduates in the CS major at Carnegie Mellon during the mid to late 1990s. Research described in *Unlocking the Clubhouse* (along with other factors

to be described in chapter three) contributed to a dramatic change in Carnegie Mellon's admissions criteria for the CS major which subsequently led to a striking increase in the number of women enrolling in CS in 1999.[7]

The literature on women in CS in the United States painted a bleak picture, and according to current data—with few exceptions—it continues to do so. Undergraduate women across the country report being told by their male peers that they do not belong in the field and are often accused of *stealing* the places of more qualified men; the women report feeling uncomfortable, unqualified, and isolated. The experiences of many women students in CS, including the *past* experiences of some women at Carnegie Mellon, made for discouraging reading. The odd woman who entered the field and had happy experiences appeared to be an anomaly, an exception to the rule.

But the more Carol read about women's experiences in CS the more baffled she became. These readings challenged her observations. They provoked many discussions with Carol's mentor and expert in the field, Lenore Blum. The disparity between the successful women students they were seeing and working with in the School of Computer Science, and the dismal picture of women's experiences as portrayed and described in *Unlocking the Clubhouse* was particularly striking. Even more disturbing was that the prevailing analysis from studies across the nation reinforced this dismal picture of women in CS—a picture of women's declining interest and participation in the field. Young women across the nation were feeling like they did not belong in computing and few were applying to major in CS.

So how could it be that Carol felt she was working with so many exceptions to the rule?

She found herself working in a top ranked CS research school with a good gender balance; a school admitting, retaining and graduating a greater percentage of undergraduate women in CS than many similarly ranked schools. Many women were, and still are, enthusiastic about CS and feel at home in the school. Students share their passion for CS but also explore their other interests. The collective student body benefits and advances its CS skills by sharing advice, collaborating on work, and by avoiding some of the most destructive patterns of gender bias exhibited in some CS departments. This is not to imply that all gender bias has been eliminated at Carnegie Mellon, that would be delusive, nor do we

imply that Carnegie Mellon students do not face many of the same kinds of problems and issues that most students face as they deal with the challenges of academic life—and life in general. Of course they do.

But clearly, from 1999 onwards some dramatic changes had occurred at Carnegie Mellon, changes which contributed to a successful undergraduate experience and outcome for many students in CS—women and men. What was going on at Carnegie Mellon and what had changed to bring about such a clear Women-CS fit? We use the phrase *Women-CS fit* to refer to the situation in which women fit into the CS micro-culture, are an integral part of that culture, contribute to it, and are successful in the field alongside their male peers—without compromises to academic integrity or by accommodating what are perceived to be "women's" learning styles and attitudes to CS.

Changing the Field?

Many research papers on women in CS in the United States point to the same reasons for women's low participation in the field. In brief, it is argued that there are strong gender differences in the way girls and boys, or men and women, relate to the field; gender differences that work in favor of men and against women. Women, we are told, want to do useful things with computing, directing their skills to more socially conscious/socially beneficial ends, while men are quite happy to focus on programming and "playing" with the machines. Computing is defined as a masculine field occupied by male geeks. The CS major, we are told, generally supports this perception thus men find the field very attractive while women do not. Furthermore, women may even be actively discouraged from entering the field. To solve this problem and increase women's participation in CS it is suggested that we need to pay more attention to women's interests and attitudes and change CS accordingly.

Challenging the Stereotypes

The more we read and worked with women in CS, the more we began to question the assumptions and constraints of the prevailing research. Several questions came to mind, which prompted continued discussions and observations.

First, by default there are few women in CS, so most of the studies explaining women's low participation in the field are conducted in situations where the numbers of women are low. Do such findings tell us

anything significant about the general attitudes of women towards CS? Or, what seems more likely, do they tell us something about their attitudes towards CS when they are few in number? So, could the ratio of men to women be affecting the attitudes and experiences of students? By 2002 Carnegie Mellon certainly had better than average ratios of women to men among undergraduates. Could this be making a difference?

Second, among explanations for women's low participation in the field there seemed to be an emphasis on *attitudes towards programming* when trying to examine student *attitudes towards CS*. This struck us as a very narrow view of CS as it excluded the breadth of research in theory and applications. In any case, we had not heard more women than men saying they did not relate to, or enjoy, programming. So, could the way CS was being taught and defined be making a difference?

Third, it seemed that people in the field are influencing the field from the inside, by being a part of CS and shaping the CS culture and environment. So, are undergraduate women at Carnegie Mellon feeling included in this cultural change process rather than feeling marginalized?

Last but not least, many of the undergraduate men at Carnegie Mellon did not appear to fit the narrow computer centered geeky CS stereotype. Indeed, many of them appeared to be very sociable and have broad interests outside of computing. So, was the student body itself making a difference? Was the admissions process a part of this difference?

What we saw (and continue to see) at Carnegie Mellon appeared to be challenging many of the images and stereotypes surrounding CS and those working and studying in the field. Furthermore we did not see the range of gender differences that have been used to explain the low participation of women in CS.

Not a Universal Problem

As Carol's investigations dug deeper into the literature, she came across an ACM paper describing what was happening on the small island nation of Mauritius where women were participating and graduating in CS in numbers representative of the general population. This paper led her to other studies of women in CS around the world. In 2002, she met a professor from Israel who told her about findings from studies in high schools in the Israeli and Arab-Israeli sectors of Israel. These cross-cultural investigations suggested, as the Mauritius study pointed out

"while the problem is wide-spread, the under representation of women in CS is not a universal problem. It is a problem confined to specific countries and cultures" (Adams et al., 2003, p. 59). Thus, factors relating to different countries and cultures appeared to be playing a role in women's participation in this field, factors that were unrelated to deep-rooted gender differences or gendered attitudes to CS but rather relating to different experiences of CS in different cultures and different situations.

For example, cultural factors were clearly at work in the study carried out in Israel, a country where the CS curriculum is very similar to that of the United States. Researchers looked at the gender balance in CS in high schools in two sectors—the Jewish sector and the Arab sector, both in Israel. Which sector—the Israeli Jewish sector or the Israeli Arab sector—would you guess had the highest proportion of girls in the CS classes? Did you guess the Jewish sector? Why? Is it because you perceive Jewish culture to place high value on education or maybe because you perceive Arabic culture as more restrictive for girls? Whatever the reason if you thought the highest proportion of girls in the CS classes was in the Jewish sector you would be wrong. In the Jewish sector 28% of the students were female, while in the Arab sector 61% were female. We suggest that such an example challenges our cultural perceptions (it certainly challenged ours) and at the same time illustrates that in some situations girls are well represented and participating in CS.

As our investigations progressed we came across other stories of women's success and participation in CS—although these were not the norm by any means. What was particularly interesting was that the majority (but not all) of the western "developed" nations were the places where women and CS did not seem to have a happy union. So how could it be that an Arab-Israeli schoolgirl, or a young woman from Mauritius, could study CS in high school or university as if it was no big deal, while in Denmark, for example, and the United States, young women are feeling out of place in CS? And how is it that Carnegie Mellon, known as a bastion of CS geekiness and high tech, could sit alongside the success stories?

A New Partnership

Jeria Quesenberry joined the Carnegie Mellon Information Systems faculty in 2007, and it quickly became clear that we shared similar perspectives on women in computing. This in spite that we come from very

different backgrounds, a generation apart: Jeria, a young mother from northwestern Montana and Carol, from England, and now a grandmother of four little girls.

We shared professional and personal experiences and reflections on the cultural factors at play among girls and young women making decisions about technology careers. We discussed the challenges facing women trying to rise through the corporate ranks—a conversation reinvigorated by Facebook executive Sheryl Sandberg's (2013) book *Lean In*. Even with its excessive *pinkness* we were excited to see Barbie become a computer engineer and for Lego to release its first female scientist! (The 126th career Barbie was a computer engineer, chosen by half a million Barbie fans[8] and Lego's Minifigure Series 11 includes a female scientist[9].)

Yet we lamented at the setbacks and negative cultural portrayals of women in technology, which too frequently outshine the achievements. A 2005 incident springs to mind, when then Harvard president Lawrence H. Summers suggested the under representation of women in tenured positions in science and engineering was due to "issues of intrinsic aptitude" between men and women rather than socialization or discrimination. Or the 2013 fiasco when the popular clothing store, Children's Place, released a shirt resplendent with hearts and girlish cursive claiming: "My best subjects: Shopping ☑ Music ☑ Dancing ☑ Math ☐ (Well Nobody's Perfect)."[10] We also expressed frustration with a media that leaps on any pseudo-scientific study that even remotely suggests innate differences between male and female aptitudes and abilities… and yet, when those studies are roundly debunked, they simply fail to follow up with the corrected information.

The reflections above, along with our observations and experiences working with women in computing at Carnegie Mellon, motivated us to engage in further studies to assess the changes we had observed. We began presenting and publishing on the topic together extending the work of Blum and Frieze and sustaining the call to focus on culture and environment. Ultimately, our journeys lead us to develop this book to tell the story of women in the School of Computer Science at Carnegie Mellon.

As a professor in the field Lenore Blum continues to be a leading role model for women in CS. She also remains committed to *Women@SCS* helping to get new interventions for women's success in CS off the ground. Lenore's experience and philosophy regarding women in math

and CS have helped sustain the programs and activities organized by Carol and *Women@SCS*. In particular, Lenore had observed how easy it was for women, being a minority in the field, to miss out on opportunities more readily available to the male majority. This observation provided the foundation for many of the programs designed and developed by *Women@SCS*.

At the same time Lenore Blum has worked tirelessly to raise entrepreneurial collaborations between Carnegie Mellon and the city of Pittsburgh to new heights. Lenore is the founder of Project Olympus and more recently her leadership helped create a new center at Carnegie Mellon, the Center for Innovation and Entrepreneurship (CIE). These efforts are contributing to the changing face of Pittsburgh. The city is shedding its industrial steel-age image and quickly becoming an enterprising home for tech start-ups and information technology advances in its established industries.

The Dynamics of Culture and Gender

The gender difference mindset—epitomized by the bestseller *Men are from Mars, Women are from Venus* (Gray, 1992)—has a strong hold on public thinking in the United States and many parts of the Western world. As recently as January 2014 an article in the New York Times by Seth Stephens-Davidowitz, Contributing Op-Ed Writer, illustrated that such gender difference thinking is still prevalent:

> MORE than a decade into the 21st century, we would like to think that American parents have similar standards and similar dreams for their sons and daughters. But my study of anonymous, aggregate data from Google searches suggests that contemporary American parents are far more likely to want their boys smart and their girls skinny. (Stephens-Davidowitz, 2014, para. 1)

At the same time this mindset is constantly having to face up to its inadequacies and contradictions as women show themselves to be strong participants in many fields which were once closed to them on the grounds of biology and perceived innate characteristics. Research studies also show that men and women are not as different as popular wisdom would have us believe. Diane Halpern's review of math and cognitive tests led her to conclude that any differences in boys' and girls' cognitive skills are so small as to be insignificant (Halpern, 2000). The extensive

work of psychologist Janet Shibley Hyde led her to argue "(i)t is time to consider the costs of overinflated claims of gender differences. . . . Most important, these claims are not consistent with the scientific data" (Hyde, 2005, p. 590).

Our experiences, research studies and observations at Carnegie Mellon also found many more similarities than differences in the way our students relate to CS. Thus, we are interested in shifting the conversation away from gender *differences,* which often lead to recommendations to *accommodate those differences.* In doing so, we not only risk perpetuating a gender divide but also risk contributing to an essentialist position in which culturally produced differences are seen as intrinsic, or natural, to men and women. Gender is first and foremost a cultural issue not a women's issue, so rather than looking at "differences" as our working model we need to address the underlying culture in which opportunities for equality are situated. While our primary focus is on the cultural conditions that contribute to the representation of women in CS we maintain that such conditions may also contribute to greater participation among other under represented groups.

This may be a good time to let our readers know what we are *not* saying. We are not saying that men and women are the same—that there are no differences—clearly our bodies indicate this—but we are saying that in some environments there may be more similarities than we realize. Several psychologists have pointed out: "a focus on factors other than gender is needed to help girls persist in mathematical and scientific career tracks" (Hyde and Linn, 2006, p. 599). Most importantly we stress "gender differences are not general but specific to cultural and situational contexts" (Linn and Hyde, 1989, p.17).

Several caveats. Women (and men) are not single separate categories and yet we are as guilty as anyone for using the term "women" (and "men") in our writings. We are limited by our language and have yet to find a more efficient way to explain our ideas. That said we want to emphasize that we are all shaped by complex identities—including such factors as race, social economic background, sexual orientation, and ethnicity— and our experiences are subject to the values, attitudes and behaviors of the culture at large as well as the micro-cultures we inhabit (e.g. family, school, peer group). Also, it is reasonable to assume that a multitude of determinants are involved in anybody choosing or not choosing to do something—biological, educational, psychological, cognitive, social, etc. We are not going to untangle all of these strands, nor do we try to resolve

the frustrating nature/nurture debates. However, we lean heavily towards a focus on culture on the grounds that culture is open to change and far more mutable than nature. Finally, this book is not driven to inform theory and cultural theorists may find our definitions somewhat naïve. We are cognizant and comfortable with these limits.

A Cultural Approach

So, what do we mean by culture and what does it mean to take a cultural approach? Our working definition of culture is derived from British cultural theorist and historian Raymond Williams (1958) who tells us "Culture is ordinary, in every society and in every mind" (p. 6). Williams brought a new way of thinking about culture that did not confine it to "high art" or the prerogative of the privileged requiring specialized knowledge and understanding. Williams showed that culture belonged to everyone. It is part of our everyday experiences and being "made and remade" by us on both the personal and the societal levels: "a culture is a whole way of life."

This definition allows us to see culture as dynamic; shaping and being shaped by those who occupy it, in a synergistic diffusive process.

When Williams refers to the "ordinariness" of culture he was claiming it for us all, as part of the lived experiences of ordinary as well as extra-ordinary people. But it is also the potential "ordinariness" of culture, rife with what Virginia Valian (1999) calls "gender schemas" that can jeopardize our gender perceptions. Gender-difference assumptions easily become entrenched in our thinking and mistaken for deep-rooted characteristics appearing to be completely natural while actually being socially constructed in specific cultures.

For our purposes, the term culture refers to the complex and broad set of relationships, values, attitudes and behaviors (along with the micro-cultures and counter-cultures that also may exist) that bind a specific community consciously and unconsciously. This community can be localized in the micro-culture of a department or as extensive as the culture of a nation. While a dominant culture may embrace and influence a broad community, counter or micro-cultures may exhibit unexpected features (as is the case of the CS micro-culture at Carnegie Mellon). In all cases this definition posits that culture is bound by context and history and that we are born into specific cultures with prevailing values and structures of opportunity. This reminds us that in the 1940s, somewhat

ironically, women were perceived as the best fit for programming: "Programming requires lots of patience, persistence and a capacity for detail and those are traits that many girls have" (Gurer, 2002, p.176).

A cultural perspective can both broaden *and* focus our thinking. It can broaden our thinking to encompass learning from different cultures, and it can focus our thinking as we identify specific factors affecting specific situations. A cultural perspective can be brought to bear on a local level as in our account of changes in the culture and environment in Carnegie Mellon's School of Computer Science, or on a broader level when we look at cultural attitudes in other countries.

Vashti Galpin (2002) describes the participation of women in undergraduate computing in more than 30 countries concluding that "(t)he reasons that women choose to study computing will vary from culture to culture, and from country to country" (p. 94). She also reminds us that when we are "seeking solutions for women's low participation in computing, it is important to consider all cultural and societal factors that may affect this participation" (p. 94). German professor Britta Schinzel (2002) also looked at female enrollment in CS around the world reporting it as "culturally diversified" and noting a multiplicity of reasons accounting for higher and lower rates of female participation. As gender is often constructed differently in different cultures taking a cultural approach allows us to see quite clearly and convincingly that many characteristics ascribed as natural to men and to women are actually produced in a culture.

We examine a range of cultural factors as determinants of women's participation in CS including the parts played by the K-12 curriculum, opportunities for engagement in CS, gender ratios, cultural myths and stereotypes. Claude Steele's (1999) research on stereotype threat is particularly relevant. This work recognizes the value and possibility of creating environmental and cultural "niches" in which women and minorities can succeed in white male-dominated fields, and without compromising academic integrity. We suggest that Carnegie Mellon's School of Computer Science has created a micro-culture that functions as such a "niche." Indeed, most undergraduate women are integrated into the CS community, are contributing to the computing culture, and are studying and graduating successfully alongside their male peers. Given the critical role of culture and environment we believe that examining this phenomenon at Carnegie Mellon could offer insight into interventions aimed at addressing the gender imbalance in CS.

Case Studies at Carnegie Mellon University

Evidence for the critical role of culture and environment come from case studies at Carnegie Mellon, which show cultural change at the institutional level. In 1995 women made up 8% of the first year CS class. In 1999 that number jumped dramatically to 37% and to 39.5% in 2000! Since 1999 the department, while not immune to national trends, has continued to enroll and graduate women in well above national averages for similarly ranked schools across the nation. In particular our book compares the pre-1999 CS culture and imbalanced environment with the post-1999 CS culture and more balanced environment. We show how in a more balanced environment, perceived gender differences start to dissolve and we see students displaying a spectrum of attitudes, including many gender similarities, in how they relate to CS. We focus on undergraduates because it is at the undergraduate level that the majority of interventions leading to change took place and also because we can compare studies from pre and post 1999. At the same time, we cannot overestimate the positive impact of having an active group of graduate women in the School of Computer Science. Not only did they initiate connections among women across the many departments of the school, but also they have since played a major role in mentoring and guiding our undergraduate students, especially through *Women@SCS* programs. Our graduate women are exceptional role models.

The Importance of Balance

So, what are the findings that lead us to such conclusions? In the specific case of Carnegie Mellon several in-depth case studies along with ongoing observations, surveys and discussions with students and faculty, showed that improving "balance" has been the critical factor. As the environment became more balanced post-1999 in terms of gender, breadth of student personalities, and enhanced opportunities for women through *Women@SCS* the culture changed. Our studies show that as students inhabit, and participate in, a more balanced environment, and as both men and women have opportunities to contribute to shaping the culture, perceived gender differences start to dissolve and both men and women can be successful in the CS major without accommodating what are thought to be the specific interests and learning styles of women.

The Work Ahead

Our work thus far has shown that in some environments and cultures student attitudes to CS are not well represented when seen through the monocle of a gender-dichotomy. A fuller expression is revealed through a prism generating a spectrum of attitudes across genders. We cannot be complacent about the low participation of women in CS generally. Nor should we be afraid that a shift away from gender-difference based theories and practices will work against gender equity. Indeed, we argue that gender-difference messages, rife in United States culture and the culture of computing, are part of the problem—not the solution. It is time for new ways of framing how we think about student attitudes and participation in CS.

Clearly, we have a lot of work to do nationally in order to turn the situation around for improved fairness and representation in computing. At the same time, we should not ignore the fact that a great many women— faculty, researchers, staff, industry professionals, and students—from across the nation and beyond, are totally engaged in the field of CS and are passionate about their work. In spite of being under represented in the field in the United States, in spite of having to overcome being seen as "exceptions to the rule," sometimes in spite of little institutional support, many women are performing well and succeeding in CS. Indeed, Carnegie Mellon is not alone in terms of working for cultural change. While many schools and departments across the nation are *not* paying sufficient attention to what is a national issue there are other places working hard to foster environments and computing cultures that work well for women. They are also recognizing that fostering such conditions tends to improve the educational, professional, and social environment for everyone.

Women's Participation in Computing: Why IT Really Does Matter!

Women, persons with disabilities and three racial and ethnic groups—African Americans, Hispanics and American Indians—continue to be under represented in science and engineering (S&E).

– The National Science Foundation, March 5, 2013

Diversity (*or Lack of*) in Computing: The Data

The twenty-first century is only beginning to tap into the benefits that can be harvested from advances in information technology (IT), information systems, computing, and CS, and women continue to play a major role as developers, leaders and founders of multiple initiatives. Yet, despite their significant role in the computing industry, the numbers of women in the field has historically been under represented at all levels—early childhood, K-12 education, post-secondary education, and workforce and career placement.

Dreams about pursuing a career in the computing field seem to be vulnerable to early influences, and in the United States young women are influenced in a way unlike their male peers. For instance, figures show that girls use computers and the Internet at rates similar to boys. Yet, studies find that they are five times less likely to consider a technology-related career or plan on taking post-secondary technology classes (e.g., Melymuka, 2001). The 2014 National Center for Women and Information Technology (NCWIT) Scorecard reports that significantly more boys than girls take the Advanced Placement (AP) CS exams. In 2013, 56% of AP test-takers were female, yet only 19% of AP CS test-takers were female. This is significant because the CS AP consistently has had the lowest female percentage of the 37 AP exams. [11]

The picture does not get prettier when examining post-secondary education figures. From the 1970s to the mid-1980s we saw an increase in *all* students choosing to major in CS. In 1984 women comprised 37% of students graduating with a bachelor's degree in CS. This was followed by a decline as the economy took a downturn and continued until around 1990. By 1994 women comprised 28.4% of students graduating with a

bachelor's degree in CS. Men starting enrolling again as the economy picked up in the 1990s, but women's interest never returned to the level it had reached in the mid-1980s.

The turn of the twenty-first century brought what many consider to be an unrealistically high number of applications to the CS major. The technology industry was booming and many young students (no doubt also encouraged by their parents and media hype) were seduced by the potential to make their fortunes in high-tech. With the dot-com bust and a change in the market we saw a sudden and dramatic decline in applications nationwide accompanied by some misleading media information which exaggerated job outsourcing. In addition, the bombing of the World Trade Center, and 9/11, had a negative impact on applications from the international community. By 2007 enrollments in CS majors nationally had dropped by half. This was followed by several years of fairly stable enrollments before an upturn, which has continued to this day. Some researchers suggest we are heading towards another peak in enrollments, possibly encouraged by what we might call the (Mark) "Zuckerberg effect"; CS is becoming both cool and lucrative (Kumar, 2011; Miller, 2011). Although, as Kumar (2011) notes, enrollments in CS majors may be increasing but do not come close to the most popular majors on American campuses: biology, economics, and political science, pathways to medicine, business and law. The Taulbee survey exclaims a "Relentless Growth in Undergraduate CS Enrollment."[12] But women have not followed this trend nationally and their representation is still seriously low. Minority students have followed similar trends to women.

The 2014 NCWIT Scorecard reports that in 2012, 57% of all undergraduate degrees went to females. Further, 59% of the undergraduate degrees in biology, and 42% of the undergraduate degrees in mathematics also went to females. Yet, only 18% of undergraduate computing degrees and 19% of engineering degrees went to females. Again, the percentage of degrees going to women in CS is miserably low (down 79% in the number of first-year undergraduate women interested in majoring in CS between 2000 and 2012).[13] In 2013, the National Science Foundation (NSF) reported women's graduation rates in CS at a low 18%. The May 2015 Taulbee survey (reporting data from Research 1 (R1) schools for 2013-2014) shows the national graduation rates for women in CS stand at 14.1%, a huge decline since its peak of 37% in 1984.

It seems reasonable to assume that many of the factors that have been deterring women from entering the field, may also be deterring many others too. This is most noticeable when we look at the statistics in the

Taulbee survey of minority population participation rates in CS. African Americans comprise around 13% of the American population[14] but only 3.2% (down from 3.8% in the previous year) of CS graduates. Hispanics comprise 15.4% of the American population[15] but comprise only 6.8% (up from 6.0% in the previous year) of CS graduates. Clearly, minority students are also seriously under represented in CS. We have found that the conditions that work well for women tend to work well for a broader base of people, not because these factors are related to women in particular, but because they are more inclusive of a broader spectrum of backgrounds, experiences, and personalities.

It is difficult to envision a gender-balanced computing workforce given the lack of women in the post-secondary computing pipeline. In fact, according to figures from the United States Bureau of Labor and Statistics, women's representation in the computing and information technology workforce has been steadily dropping since its peak in the mid-1980s. The 2014 NCWIT Scorecard reports that women represent 55-58% of the professional occupations from 2000-2011. At the same time, the percentage of women in computing-related occupations has declined between 2000 and 2011, but more recently has held steady. Further, the rate at which women leave computing (the quit rate) exceeds that in other science and engineering fields; 56% of women in technology companies leave their organizations at the mid-level point (10-20 years) into their career—twice the rate of their male peers.

For all of us involved with gender studies in computing these numbers really matter (and perhaps for all of us in general). On the surface such data indicate little progress in spite of our huge efforts. To counter such thinking we need to keep in mind, as the National Science Foundation reports "Overall, more women than men graduate from college with a bachelor's degree" and over the past few years girls and women have turned the situation around in many science fields. For example, in 2010, women received 50.3% of all bachelor's degrees in science and engineering" (p. 2)[16]

This is good news because it clearly indicates that women can do as well as men in science and engineering fields *overall*. What the broad picture does not tell us is that in certain fields women are very poorly represented, with CS and physics awarding the fewest number of degrees to women.

Such variations in participation rates in computing suggest multiple factors including economic and political factors, both inside and outside of

academia, are at work, many of which are beyond our control. But the ups and downs of student enrollment in CS suggest *that this not a women's issue* even though the impact on women has been disproportionately higher; rather *it is a cultural issue that concerns us all.*

The Value of Diversity in Computing

Over the past few years the failure to attract and retain women in computing fields in the United States, and in other developed nations, has grown into an issue of national concern. Girls and women in the United States have caught up with boys and men as *users of technology*, but still lag behind their male counterparts as *the more lucrative producers of technology* (e.g., Huyer, 2005; Quesenberry, 2006). The low interest of women in CS has stimulated widespread attention from government agencies, from industry, and from academia, all calling for answers to such fundamental questions as why does this situation exist and what can be done about it? Yet in spite of what seems like a general agreement that the nation needs more women in the field, and numerous studies and ensuing recommendations to address these issues, *the problem persists.* Significant efforts have been directed at addressing the problem—although this book cannot fully summarize the wide body of work in this space—we point readers to the NCWIT repository of materials as a starting off point.[17] While the field continues to lose out on attracting a broad range of students, arguments noting the *value of diversity* have been growing, and growing in relation to CS in particular.

> (T)here is a pressing need to broaden participation in the study of computer science and attract the full range of talent to the field, regardless of ethnicity, gender, or economic status. Institutions should make efforts to bring a wide range of students into the computer science pipeline and provide support structures to help all students successfully complete their programs. (Computer Science Curricula, 2013, p. 47)

Increasing the participation of women in CS in the United States has been recognized as critical on several levels, ranging from moral arguments for fairness to increased efficiency and profits, and to acknowledging a national economic need. A core program mission for the National Science Foundation (NSF) includes "preparing a diverse, globally engaged science, technology, engineering, and mathematics (STEM) workforce."[18] Indeed, some of the NSF's Computer and Information Science and Engineering (CISE) programs are set up *specifically to address*

women's participation (e.g. ADVANCE[19]: "the goal of the ADVANCE program is to develop systemic approaches to increase the representation and advancement of women in academic STEM careers, thereby contributing to the development of a more diverse science and engineering workforce.[20]). Such efforts suggest a strong case for academic diversity in CS—to enrich the field and sustain strong growth, we need to include the perspectives, ideas, skills and life experiences of more women.

The Business Case for Diversity

The economic case for diversity has grown alongside the academic case. As a nation we now recognize that the technology industry is a global market and to stay competitive the United States needs to train and attract more workers in the field. Tim McAward and Megan Raftery with the Kelly Outsourcing & Consulting Group explained:

> There are a number of factors that are inhibiting new entrants to STEM fields and luring existing participants away to others. These include significant cultural, gender and attitudinal shifts and long-held notions that shape who enters (and who stays in) STEM-related educational tracks and careers. Companies themselves must understand these forces, and be aware of how they may be contributing to them if they are to be turned around. (Kelly Outsourcing & Consulting Group, 2012, p. 2)

Currently, we see a serious shortfall in the projected number of college graduates prepared to fill jobs in computing fields despite the increase in enrollments to CS majors. As Ed Lazowska (2010) explains "among *all* occupations in *all* fields of science and engineering, CS occupations are projected to account for nearly 60% of *all* job growth between now and 2018" (para. 4). The rewards are there too. CS ranks as a best-rated job among the top eight careers, with high pay and strong job growth (Ricker, 2012). With such projections it seems reasonable to assume that we need to reach out to a broader base of talent to grow the next generations of computing professionals.

There is a large body of research that points to the business case for diversity (e.g., Carroll and Shabana, 2010; Deloitte, 2011; McKinsey & Company, Inc., 2014, 2012; Quesenberry and Trauth, 2012; Trauth et al., 2006). The European Commission suggests "evidence of the business case for diversity and gender balance grows stronger by the day" (European Commission, 2008, p. 8). A 2011 *Yale Insights* article summarized

the views of many global leaders and why creating value from diversity is so critical. In this article Richard Boyatzis, Distinguished University Professor at the Weatherhead School of Management at Case Western Reserve University explained:

> I think some of the most profound diversity we experience in life has to do with diversity of thought. Diversity initiatives can have important and interesting social justice benefits, but the real reason you want to pursue diversity programs is for innovation. You want diversity of thought. Here's the key: If you want diversity of thought, you have to bring in people around you who have diverse experiences. Differences in race, gender, and socioeconomic background are three characteristics, but so are differences in learning style or differences in professional field. (Brescoll, 2011, para. 8)

Some of the large technology industries are recognizing the importance of diversity and taking the lead to bring more women into computing fields. According to the European Commission (2008):

> Microsoft regards diversity as a 'core value' of the company. "A more diverse workforce makes for better decision-making and a varied approach to product development," explains senior technical recruiting account manager Joel Graves. "Simply put, we need more women in our technical divisions." (p. 18)

There have been cases where focusing on a homogeneous population have proven to be shortsighted from both a public relations and a business perspective. For example, early voice recognition programs responded only to male voices; early seat belt technology was only effective for the male body; face detention monitors responded only to white faces; *and more*... Bringing more diverse perspectives on board is a good business model for designing products that appeal to multiple buyers. Companies have also found that a more diverse workforce can help to capture market share generated from insights of a broader customer base (Deloitte, 2011).

Of particular interest in terms of business and diversity is that new investigations suggest that *well managed diverse teams* may have the potential for increased efficiency, innovation, and profits (Chartered Institute of Personnel Development, 2006; European Commission, 2006). "When asked whether diversity initiatives have a positive

impact on their business, the vast majority (82%) of the 495 companies that replied agreed that they did" (European Commission, 2005, p. 7).

McKinsey & Company, Inc.[21] (2014, 2012, 2008, 2007) produced several intensive investigations into the role of diversity in business. The company finds that successful companies make gender diversity a priority because they see the prize: a talent advantage that's hard to replicate. They highlighted 78 best performing companies that had made significant efforts to diversify their boards and top management and found those companies consistently outperformed their peers in the Fortune 1000. Their 2008 report makes the point that "(g)ender diversity is not just a social concern. Our new study suggests that it could also create a competitive edge to address the global challenges that corporations will face in the near future" (McKinsey & Company, Inc., 2008, p. 3). The 2007 and the 2008 reports both concluded that improved gender balance was a means to improved performance in the business world. The 2007 study looked at 101 mainly large corporations from a range of industries across Europe, Asia, and the United States.

> These statistically significant studies show that companies with a higher proportion of women on their management committees are also the companies that have the best performance. While these studies do not demonstrate a causal link, they do, however, give us a factual snapshot that can only argue in favor of greater gender diversity. (McKinsey & Company, Inc., 2007, p. 16)

Other companies are finding benefits from including diversity programs, benefits they had not considered. The European Commission's report, "The Business Case for Diversity," (2005) showed surprising benefits resulting from including good diversity practices as a business priority. Benefits ranged from reduced absenteeism, reduced employee turnover, and improved corporate image. A 2007 report, "Innovative Potential 2007," from the Lehman Brothers Centre for Women in Business at the London Business School (2007), involved more than 100 teams of professionals in 21 cross-sector companies from 17 countries. The research found that *diverse teams* have the potential for increased efficiency, innovation and profits. Professional teams were at their innovative optimum when the ratio of men to women was *balanced*. The report also challenges many gender stereotypes and shows that men's and women's aspirations and attitudes towards work were very similar.[22]

Where benefits have been reported the environment has usually been *well managed* to allow for diverse individuals to work together and form effective teams (e.g., Mannix and Neale, 2005). This is an important point. Simply adding more women and minorities to a situation will not automatically result in companies finding that diversity pays off. Indeed, without thoughtful practices to formally provide an inclusive environment the potential for conflicts and misunderstandings rises, which then could backfire on diversity efforts.

Women's Participation in Computing Really Does Matter

Investigations like those carried out by Deloitte, McKinsey & Company, Inc. and Lehman Brothers endorse the idea that diversity should be seen as *a means for finding good solutions,* not a target number. Professor Orit Hazzan uses Carnegie Mellon as an academic example along with examples from industry to propose, and we agree, "it is in the interest of the computing world, rather than in the interest of any specific under represented group in this community, to enhance diversity in general" (Hazzan, 2006, p. 1). Changes in the culture of computing at Carnegie Mellon have shown that a more diverse student body, including increased numbers of women students, has enriched the social and academic environment for *everyone.*

We have seen from the data that the number of women in CS is seriously low; yet clearly the potential is there. In the United States we face the mystery of why women are not taking full advantage of the opportunities and the intellectual challenges of what is probably the fastest growing field in the nation. Why are women apparently *choosing* to miss out on a range of exciting and rewarding career opportunities? In the meantime the field is missing out on a broad spectrum of talent that a more diverse student body and workforce could contribute. Thus, it is generally argued, and agreed, that women's participation in CS really does matter. The low representation of women in CS needs to be turned around for the benefit of women, for the benefit of the field, and, with fears of the United States falling behind its competitors, for the benefit of the nation as a whole.

Arguably, concern for women's enrollment in CS foreshadowed what is now an overall concern for the field, or as Lenore Blum says "Women are the canaries in the coal mine" (Dean, 2007, para. 6). By 2007, when overall enrollments in CS had dropped by half, we started to see increased attention to the field. Declining numbers of all CS majors

brought a much needed re-examination of CS and an ideal opportunity to broaden the awareness of the myriad disciplines within CS and what the field has to offer to a diverse range of students. We believe that changing the perception of CS, and of who can succeed and enjoy CS, will go a long way to determining who will participate. But, whether it is defined by its scientific aspects or by its engineering aspects or by its career potential we need to recognize that low enrollments in CS arise from *cultural preconceptions that can limit anyone* and changing cultural perceptions has the potential to help turn the situation around.

Background and Interventions for Change at Carnegie Mellon University

My heart is in the work.

– Andrew Carnegie, November 15, 1900

Carnegie Mellon is a private research university in Pittsburgh, Pennsylvania. In 1900, industrialist and philanthropist Andrew Carnegie founded the Carnegie Technical School. Twelve years later the school became the Carnegie Institute of Technology (CIT)[23] and began offering four-year degrees. Shortly thereafter, in 1913, Andrew W. Mellon and Richard B. Mellon, both Pittsburgh industrialists and philanthropists, founded the nation's first major research institute, the Mellon Institute of Industrial Research (located close to the CIT campus). In 1967, the Carnegie Institute of Technology merged with the Mellon Institute to form what is now known as Carnegie Mellon University.

Today, Carnegie Mellon is a global research university with more than 12,000 students, 95,000 alumni and 5,000 faculty and staff. The university's specialty programs consistently rank among the best in the world and applications for undergraduate and graduate admission increase annually.

The university has seven colleges and independent schools: Carnegie Institute of Technology, College of Fine Arts, Dietrich College of Humanities and Social Sciences, Heinz College, Mellon College of Science, School of Computer Science, and the Tepper School of Business. In addition to the Pittsburgh campus, the university also has campuses in Silicon Valley, California, in Doha, Qatar, and degree-granting programs around the world, including Africa, Asia, Australia, Europe and Latin America.

Diversity as a Foundation to the University's Strategic Plan

The vision of Carnegie Mellon is to "meet the changing needs of society by building on its traditions of innovation, problem solving, and interdisciplinarity."[24] Diversity and inclusion are core-values to the university and diversity at the institutional level has been an evolving process. As former Carnegie Mellon President Jared L. Cohon shared in the Statement on Diversity: "In the classroom, studio, laboratory,

office and residence hall, a multitude of experiences, perspectives and beliefs will enrich all that we do."[25]

By 1999 the value of diversity was entering the university's lexicon. At that time, President Cohon established the Diversity Advisory Council as part of his strategic plan. Two years later he noted that "Carnegie Mellon's highest goals will be well-served by raising the consciousness of the entire university community about the inherent benefits of creating a more diverse institution and educational environment."[26]

Today, diversity continues to be a top-priority to the university—it is a community that understands that the diverse experiences, perspectives, viewpoints and backgrounds of its students, faculty and staff are the keys to ongoing innovation and intellectual creativity that is critical for solving the challenges of tomorrow. In July of 2013, Subra Suresh, Ph.D. became the ninth president of the university. In his address to the incoming class of 2017, President Suresh, noted that the class was one of the most diverse classes in Carnegie Mellon's history.[27] As in industry, where diversity is being encouraged for its value to entire companies, as a means (not a target) for solving problems more efficiently, diversity at Carnegie Mellon has not been embraced solely on behalf of women or minorities, but rather for improving the educational experience and outcome of all.[28] A sentiment echoed in writing in Carnegie Mellon's last strategic plan expresses the value of integrity and inclusion: "As exemplified by our attention to the highest ethical standards in all domains, and our commitment to being a community which welcomes talented minds from diverse backgrounds and challenges them individually and collectively to achieve their best" (p. 6).[29]

Establishing a More Balanced Environment in the School of Computer Science

Carnegie Mellon had a Computer Science Department by 1965 (one of the first departments in the nation) and by 1988 the department earned independent status as a School of Computer Science (again among the first such schools in the country). However, the undergraduate CS major was not fully integrated into the School of Computer Science until 1995, thus adding a relatively new educational program to the well-established and cutting edge CS research and graduate work that was going on.

The School of Computer Science currently houses the Computer Science Department as well as six other departments: the Human-Computer

Interaction Institute, the Institute for Software Research, the Lane Center for Computational Biology, the Language Technologies Institute, the Machine Learning Department and the Robotics Institute. The school also has close ties with the Entertainment Technology Center and many other departments on and off campus. Faculty within the school's departments represent a growing range of areas while the school reflects and embodies the philosophy that CS thrives on the interaction of diverse perspectives and expertise. Although the connection between this philosophy and having a diverse student body may not be apparent to all at first, these perspectives clearly mesh and can serve to support each other. Thus with time, this connection is more likely to be understood and accepted, even championed, by a significant constituency of the community, as happened at Carnegie Mellon (Blum and Frieze, 2005a). Deans of the School of Computer Science, from Raj Reddy to James Morris to Randy Bryant to Andrew Moore, have been, and still are advocates for promoting diversity in the school and the university.

The story of women in CS at the undergraduate level might be said to begin in 1995 when the low representation of women in the major became a matter of great concern for some members of the CS faculty. In particular, Allan Fisher, then Associate Dean for Undergraduate Computer Science Education, initiated a research study in collaboration with Jane Margolis, a social scientist and expert in gender equity in education. Their study, funded mainly by a grant from the National Science Foundation (NSF) and the Sloan Foundation carried out between 1995 and 1999, set out to assess gender differences in the attitudes towards CS among the school's undergraduate majors. Their aim was to understand why women were so few in number and with better understanding arrive at recommendations for improving the gender balance at the undergraduate level. Their research findings proved to be of critical importance. The most significant finding showed that prior experience with programming was *not* a pre-requisite for completing a bachelor's degree in CS (Margolis and Fisher, 2002). This finding confirmed what Berkeley's re-entry program had found back in the early 1980s when Berkeley created a pathway into CS graduate programs for "bright students who had concentrated in subjects other than computer science at the baccalaureate level" (Humphreys and Spertus, 2002, p. 53).[30] The Carnegie Mellon studies provided research backing for interventions in admissions to the CS major that proved to be pivotal.

Another factor that contributed to change at Carnegie Mellon was an outreach program, 6APT, for high school CS Advanced Placement teach-

ers that combined technical training with discussions of gender gap issues (Blum, 2004; Margolis and Fisher, 2002). These particular outreach efforts were dropped in the late 1990s after National Science Foundation (NSF) funding expired. Similar outreach efforts were picked up again in 2006 by the organizers[31] of Computer Science for High School (CS4HS), which included a diversity component. CS4HS ran for eight years at Carnegie Mellon, sponsored primarily by Google. CS4HS aimed "to reach out to high school (and K-8) teachers to provide resources to help them teach CS principles to their students in a fun and relevant way."[32]

Perhaps the most significant person for influencing change in CS in the late 1990's was Raj Reddy, then Dean of the School of Computer Science. His vision for the future of CS at Carnegie Mellon and his institutional support were exceptional. Students enter Carnegie Mellon's CS major in their first year and admissions are made through the university. As the 1990s research findings were being gathered, Raj Reddy asked the Office of Undergraduate Admissions to develop criteria that would select for future leaders and visionaries in the field. One subsequent criterion gave value to "evidence of giving back to the community." Carnegie Mellon adopted this *broadened* admissions policy, emphasizing diverse interests along with high achievement in mathematics and science (high SAT scores were still required) and de-emphasizing prior programming experience.[33] According to the Director of Carnegie Mellon's Admissions Office, the admissions criteria has continued to focus on the "student as a whole," looking for such things as community service and indications of leadership potential, while all the time keeping high SAT scores as a primary criteria. In many cultures, including the United States, women are often the ones who are encouraged to "give back to the community." Given this perspective we might well argue that the admissions criteria were somewhat biased towards admitting more women—and indeed this is what happened in 1999.

These interventions opened the doors to a dramatic increase in the numbers of women in the CS major (as mentioned earlier, from 8% in 1995, to 37% in 1999, to 39.5% in 2000). After brief declines[34] following the dot-com bust when all applications to CS programs dropped nationwide the enrollment of women at Carnegie Mellon has been fairly steady over the past few years, representing 29%, 34% and a projected 32%, of the 2012, 2013 and 2015 first year classes respectively, and an unprecedented 40% in 2014. Carnegie Mellon went from being among the schools with the lowest percentage of undergraduate women in CS in the United

States to one of the universities with the highest percentage. Furthermore, it subsequently succeeded in building a culture and environment that allowed for a good Women-CS fit. What's more the School of Computer Science succeeds in sustaining and graduating a very high proportion of the students who enter as first year CS majors. Indeed, the persistence rate for men and women is almost identical. According to data from Carnegie Mellon's Office of Institutional Research and Analysis, in the last four cohorts that completed six years, the average graduation rate was 89% with no difference between the rates for men and for women.

At the time of the revised admissions criteria, and something not usually noted in discussions about diversity in CS at Carnegie Mellon, the doors were opened to a different kind of male student, selected, as were the women, for their leadership potential, community service, and high SATs. Thus, the Computer Science Department began to see *a more diverse student body overall*. This was well expressed in 2002 by Professor Peter Lee (at the time Associate Dean for Undergraduate Education; Head of the Computer Science Department 2007-2009) who noted that the "de-emphasis of prior programming experience didn't have anything to do with gender. Having a mix of people around him or her makes a student feel better—it inspires them. Students learn a lot from each other, so you want an interesting mix."[35] On the surface diversity as a means to make students "feel better" may sound trivial. But in effect it contributes to an enriched learning environment in the same way that diversity contributes to a more successful business model.

All of the above interventions opened the way for *an interesting and more balanced environment* in the post-1999 Computer Science Department. Improved balance is reflected in three major domains: gender, students with a breadth of personalities/interests, and professional and social opportunities for women (through the organization *Women@SCS*) to reflect the opportunities more readily available among the majority male students. We believe the multiple-levels of commitment and interventions described above were crucial for changes to be successful. What's more this continued commitment ensures continued success.

While discussing interventions for change it is also critical to note what was *not* changed. Academic entry-level standards were not lowered to accommodate student diversity. Students who had no background in CS still needed high SAT scores and were for the most part already on

a math/science track. As faculty began to recognize the increased presence of women, their strengths and their potential to be good computer scientists the school started paying serious attention to the future of the undergraduate program. What we have to remember is that the existing program was geared towards a particular type of student, usually male and with some programming background. New courses were introduced to accommodate students entering the major with little or no background in CS. Any other curriculum changes were made to enhance the educational experience of a broader student body *not* to accommodate women's presumed interests. Since that time any changes to improve the curriculum have been made for the benefit of *all students*, and are the kinds of changes that go on in any department committed to providing the best academic program possible.

While Carnegie Mellon has a great record for gender balance in CS we would be remiss if in telling the story of women in computing at Carnegie Mellon we gave the impression it was a perfect story. While transfers out of CS are very few, female students transfer out of CS at *slightly* higher rates than male students while more male students transfer *into* CS from other departments. Thus, when we look at one year's graduation data we see a much lower percentage of women graduating with a bachelor's in CS. However, this does not give the whole picture. *When we examine the persistence rates of individual students there is no difference in the graduation rates of men and women.* Worth mentioning again, and quoting Carnegie Mellon's Director of Institutional Research and Analysis: "In the last four cohorts that completed six years, the average six-year grad rate was 89% with no difference between the rates for men and for women."

While there are many factors involved in the decision to transfer, for students coming into the CS major we need to recognize that many enter with little, if any, background in the field. Thus, for some students a CS major is a shot in the dark: they may find a terrific CS-fit or find it's just not what they anticipated. The good news is that most of the students who transfer are not lost to computing fields; they move into other technical programs at Carnegie Mellon, for example they may enter the Information Systems Program in the Dietrich College of Humanities and Social Sciences, or they may transfer their CS focus to the Bachelor of Computer Science and Art (BCSA),[36] an intercollegiate program which melds technology and the arts.

Valuing and Investing in Diversity in Computer Science

In 1999, when Lenore Blum joined the CS faculty at Carnegie Mellon she set about formalizing a program which would help ensure that undergraduate women would thrive in what was then a very traditional CS culture. The newly formed organization was called *Women@SCS*.[37] It has since become catalytic in building an environment in which the student body can flourish. *Women@SCS* also embraced graduate women students who had become pro-active prior to 1999 in recognizing the need for connecting women across all departments in the School of Computer Science. The initiatives of students at the very beginnings of *Women@SCS* were indicative of how student driven so many of the programs would be. The appointment of Lenore Blum, along with dedicated funding for a program of professional and social activities for *Women@SCS* indicated the school's commitment to women's success in CS at Carnegie Mellon. Carol joined the School of Computer Science in 2000 as Associate Director for *Women@SCS* and became Director of the organization in 2004, a position she continues to hold. And this reflects a very important concept: *Women@SCS* was not left to develop as a marginalized women's group, rather it was embraced as a professional organization to be integrated into the school as a valuable asset.

Improved gender diversity has benefited the entire Computer Science Department by enhancing the academic and social atmosphere for everyone. Indeed, researchers have found that "social compatibility with the domain" (Steele, 1997, p. 625), in this case the school, contributes to academic success. According to Professor Peter Lee, by 2002 the faculty had finally begun to notice the positive impact that diversity was having on the School of Computer Science, "faculty is beginning to understand that having a mix of men and women makes our program better. It's become a source of pride and enthusiasm."[38]

Several School of Computer Science faculty members directly involved in teaching the CS undergraduate core courses have been with the department since the mid-1990s. In interviews and conversations they have provided interesting observations on computing culture, diversity, the student body, departmental atmosphere, and other changes they have noticed over the years. (Please see Chapter 4 for more information about data collection efforts). For example, several faculty members confirmed that the 1999 interventions for change and the shift towards a more balanced environment had benefited the department as a whole. Other faculty commented specifically on the blurring of the programming/applications divide among women and men, a divide noted in

research studies done prior to 1999. Faculty also noted that in general students had moved from being very CS focused to showing a range of cross-campus and general outside interests.

Several faculty members thought the increased numbers of women had significantly improved the quality of student social life. Interestingly, the nature of students' complaints to faculty advisors changed. Before the increased numbers of women the major source of complaints revolved around *social life*, afterwards the major source of complaints revolved around *grades*. Thinking back to the pre-1999 culture it is easy to accept that the few women students would have felt like they did not fit into the lopsided environment, but it is misleading to think that *all* the men were content. While it may have been conducive to the academic success of the mostly male students, the imbalance did not provide a particularly rich social environment for most students regardless of gender.

Several faculty members noted that students had become increasingly grade obsessed and felt this related to the focus on improving their test taking ability in high school, to the detriment of building critical thinking skills. The students, said one faculty member, often struggled with reconciling their high school understanding of CS and the new understanding of the field as it is taught at Carnegie Mellon, especially when they first came up against the more abstract courses like Fundamental Data Structures and Algorithms.[39] But when they "got it" they were thrilled and excited.

On a similar note at least two faculty members pointed out that it was not just women who felt like they did not fit into the pre-1999 culture, some men felt the same way. One faculty member described the general environment as "sink or swim" which worked against the handful of male students who were admitted with little programming background. He suggested that when the department started to address gender issues in the late 1990s it raised the possibility of making improvements for *all* students. Another faculty member remarked that the changes in the department caused "a 180 degree turn around" in climate and student happiness. Faculty-advisors played a major role in ensuring a positive academic and social experience for all students. We heard many student comments, which testified to this: "the advisers are amazing"; "[advisors] create an extremely comfortable atmosphere."

Another faculty member felt that the biggest impact the increased numbers of women had on the department was to change the self-image of

the department and the school, as well as outsiders' views of CS at Carnegie Mellon. In terms of self-image, the improved gender balance helped students and faculty shift away from the culture's "nerd" burden—seeming to be only interested in CS—to allowing space to share other areas of interest. The implementation and success of SCS Day is a good example of this new freedom. SCS Day, initiated by *Women@SCS* in 2004 and now organized by an "SCS Day" committee of students, is a celebration of the non-computing skills of students, staff and faculty. All members of the School of Computer Science community are invited to attend. SCS Day activities have included dancing, juggling, karate, bicycle repair, squash, and an art show. This annual event concludes with an auditorium-packed talent show with the dean of the School of Computer Science, or other senior faculty, acting as master of ceremonies.

Several faculty (and administrators) commented on the valuable role played by *Women@SCS*. One senior faculty member stated strongly that *Women@SCS* has been crucial for retaining women in the undergraduate CS student body. While *Women@SCS* works primarily to improve the social and professional opportunities of women, faculty applauded the organization for helping bridge the various departments within School of Computer Science, building a community, and offering events that strive to be inclusive of *all* students.

Other indications of broad cultural change within the school were noted. Young faculty from throughout the School of Computer Science started to meet as a group to share ideas and discuss their social and professional interests. Young women faculty started to meet as a group bringing together non-tenured women from across all departments of the School of Computer Science. This is reminiscent of the early days of *Women@SCS* when graduate students from throughout the School of Computer Science starting meeting and making connections.

Admittedly, while Carnegie Mellon has been successful in improving the gender balance of the Computer Science Department, there is much work to be done in terms of recruiting and retaining a population reflecting ethnic diversity; working towards broader diversity would seem to be the next natural steps for a school which embraces and thrives on creativity and innovation. In line with this philosophy, in the fall of 2013 the School of Computer Science announced the formation of a new organization, SCS4ALL, to be led by *Women@SCS*.

In summary, changes in the culture and environment at Carnegie Mellon did not emerge in isolation, nor did change simply happen; faculty, students, and staff have all played—and continue to play—a vital role. Indeed, as Margolis and Fisher assessed changes before they left their roles at Carnegie Mellon in 1999 they recognized that "the key to the longevity of these changes, though, is the recruitment of the faculty and students to continued environmental improvements" (Margolis and Fisher, 2002, p.139). Interventions went on at the individual level, the departmental level and the institutional level, and, most importantly, had institutional support as well as departmental and individual support. These changes are the result of fresh initiatives and vision along with thoughtful teamwork, and both human and financial resources. Changes at Carnegie Mellon have made the culture of computing more inclusive of a broader population of participants. Our School of Computer Science story can contribute to re-defining the understanding of who can succeed in CS without appealing to the perceived stereotypical interests of women, or men for that matter.

Case Studies at Carnegie Mellon University

*When men and women are in similar situations, operating under
similar expectations, they tend to behave in similar ways.*

– Rosabeth Moss Kanter, 1977

Overview of the Case Studies at Carnegie Mellon University

The School of Computer Science's history offers us an ideal opportunity
to examine both the pre-1999 *imbalanced* situation and the post-1999
more *balanced* situation; balance defined in terms of gender, breadth of
student personalities, and enhanced opportunities for women.[40] Several
case studies of undergraduate students in CS at Carnegie Mellon have
been conducted during the past two decades: the pre-1999 longitudinal
study, and then studies in 2002, 2004, 2009-2010 and 2011-2012. The
latter post-1999 individual case studies represent "snapshot" research
points—each motivated by and conducted with specific objectives. A
consistent element of all of the studies is the theoretical underpinnings
of a social construction perspective. Hence, when these studies are holis-
tically analyzed, the findings paint an understanding of the ongoing
shaping of the culture of computing at Carnegie Mellon.

Pre-1999: Research findings from studies at Carnegie Mellon in the mid-
late 1990s, when women comprised between 8% and 15% of the CS stu-
dent body, suggested that there was a strong gender divide in men's and
women's attitudes towards CS. While poor gender balance was not the
only factor at work, in this gender imbalanced environment women
reported feeling like they did not fit into the computing culture, their
confidence was low, and many smart, capable women left the program
without completing their studies (Margolis and Fisher, 2002).

2002 and 2004: By 2002, changes in the culture of computing were
already being observed in the School of Computer Science. The situation
from 2000 onwards clearly warranted closer examination so with a grant
from the Sloan Foundation we set about conducting an initial case study.
The findings were so striking that we carried out another case study in
2004. The latter not only confirmed our 2002 findings, that students
demonstrated a spectrum of attitudes along with many similarities, but
also led us to challenge some of the traditional thinking about women
and men in computing.

2009-2010 and 2011-2012: Since 2004 we have continued to monitor the culture and environment carrying out additional interviews and surveys in the academic years 2009-2010 and 2011-2012. As with our initial study in 2002, our 2011-2012 study was prompted by change, in this case a newly revised curriculum providing greater emphasis on theoretical thinking. We wanted to assess the impact of the change on the academic and social fit of CS students, looking in particular for any red flags that might indicate problems with the Women-CS fit (Frieze and Quesenberry, 2013; Frieze et al., 2011).

Table 1: Overview of Case Studies at Carnegie Mellon University

Year	Qualitative Research Approach	Participants	Funding Source
1995-1999	Interviews Observations Discussions	Over 230 interviews with over 100 undergraduate men and women in CS	The National Science Foundation The Sloan Foundation Spencer Foundation
2002	Interviews Observations Discussions with faculty, staff and students	Interviews with 33 undergraduate men and women seniors in CS	The Sloan Foundation
2004	Interviews Surveys Observations Discussions with current CS faculty (especially faculty who had been around in the 1990s), staff and students	Interviews with 55 undergraduate men and women seniors in CS Surveys with 136 undergraduate students (27 women and 101 men) Surveys with four women and three men who transferred out of CS between fall 2001 and fall 2004	Interviews funded by the Sloan Foundation Surveys were funded by a grant from the Computing Research Association's Committee on the Status of Women (CRA-W), and Collaborative Research Experience for Undergraduates (CREU) Program

Year	Qualitative Research Approach	Participants	Funding Source
2009-2010	Surveys Focus groups Observations Discussions with students	Surveys with 259 undergraduate students (58 women and 201 men) Focus groups with 6 undergraduate and 18 graduate students	CRA-W and CREU
2011-2012	Interviews Surveys Observations Discussions with students	Interviews with 40 undergraduate sophomores (20 women and 20 men) in CS Interviews with four students and email responses from two students who switched out of CS but remained at Carnegie Mellon Surveys with 200 undergraduate students (52 women and 148 men)	Microsoft Research-Carnegie Mellon Center for Computational Thinking, and Carnegie Mellon's School of Computer Science

Unbalanced Gender Representation: 1995-1999 Case Study

Prior to 1999, the admissions policies, as well as the culture of computing supported a specific type of (male) student, in particular those who had exhibited great programming proclivity. Research conducted at that time (1995-1999) found a gender divide in the CS fit; in sum men were more likely to feel at home in the Computer Science Department among their likeminded peers while the small number of women often felt out of place. The studies also concluded that there were strong gender differences in the way men and women were relating to CS, men were more likely to be focused on coding and the machine itself, while women wanted to do something useful in terms of applications. This finding was summarized as a gender divide: "computing with a purpose" (women)

and "dreaming in code" (men), and has been circulated widely as such (Margolis and Fisher, 2002).

As earlier stated, some of the findings from this early study contributed to the significant change in admissions criteria to the CS major—such as minimizing the need for previous CS programming experience. These changes fit well with former Dean Raj Reddy's vision to broaden the scope of the search for potential CS talent which ultimately helped increase the numbers of women entering as first year CS majors.

One of the major recommendations arising from the 1995-1999 study was based on the conclusion that men and women students held very different attitudes towards CS. Thus, it was recommended that to increase the participation of women in CS we should be asking, "How can CS change to attract more women?" (Margolis and Fisher, 2002). Their recommendation was to contextualize the curriculum, to make it more applications based on the grounds that this would appeal to more women. Other researchers have also suggested that making coursework meaningful and relevant would increase the appeal of CS to more students. NCWIT's top ten ways for retaining students in computing notes that "students learn more when what they are learning is relevant to their life..."[41] We agree that this is a powerful argument. But we also want to make it clear that this is not just about women. Most of us, men and women, often struggle with abstraction and find learning that is "relevant and meaningful" more manageable. That said, at Carnegie Mellon (and we assume at most schools) academic studies require and value abstract thinking and opportunities for theoretical design. CS is no exception.

Again, it is often assumed that Carnegie Mellon changed the curriculum to be "female friendly" and has continued to do so since 1999 in order to increase the numbers of women in the undergraduate major. *But this is not the case.* Indeed, if anything, over the past few years CS coursework at Carnegie Mellon has become increasingly abstract and more theoretical, especially in the first and sophomore years of the CS major. For the most part the School of Computer Science faculty believe that incorporating applications into a particular course should depend on whether it makes sense for the subject matter, for the intellectual and technical skills to be developed, and/or for pedagogical purposes—*not* as a presumed means to promote gender equity (Blum and Frieze, 2005b).

A Class in Transition: The 2002 Case Study

Changes in how our students were relating to CS were already being observed by 2002 when we conducted interviews to examine the perspectives of a class in "transition." We called this group of seniors a class in transition because this was the last class to have entered the program before there was anything close to a critical mass of women. They entered the program in 1998 when the entering class was on a par with the low numbers of women entering CS programs nationally. The classes ahead of them also had a low female to male ratio. However, the classes following behind them from 1999 onwards, with the new admissions criteria now in place, had good gender balance (the 1999 class entered with 37% women).

Our goal was to understand how cohorts of CS students at Carnegie Mellon perceived their relationship to the field. Hence, we took an ethnographic, qualitative approach, which is commonly used to further the understanding of how members of communities respond to specific phenomena (e.g., Babbie, 2004; Maxwell, 1996; Trochim, 2005). The data collection tools included face-to-face interviews, discussions and observations, with interviews providing the primary data. Indeed, interviews, using an adaptation of the interview questionnaire used in the 1990s research,[42] allowed us to assess change. The interviews were very open ended and meant to solicit perceptions and comments from the undergraduates who participated; undergraduates who are viewed as the expert informants on their experiences and attitudes (Seymour and Hewitt, 1997, pp. 13-14). We used traditional qualitative processes for the analyses and evaluation of the data (i.e. listening, reading, categorizing, interpreting, and describing) along with quantitative data analyses where appropriate.

We interviewed 33 seniors (17 women and 16 men) from the class of 2002. In our analysis of the interview data, we found that the gender divide that characterized the 1995-1999 findings had largely dissolved. In its place, we saw students demonstrating a spectrum of attitudes, and, most surprisingly, many similarities in how they were relating to the field. Indeed the two social scientists, Larsen and Stubbs (2005), who were hired to analyze the 33 interview transcripts independently, soon observed that focusing on gender differences could not provide adequate conclusions for what they were finding:

> The original objective of this study was to locate and identify gender differences in the perceptions of these students. Our

diligent attempts to meet this objective were consistently frustrated by **the clear existence of gender similarities** [emphasis added] and evidence of other sources of diversity. (p. 140)

When we compared our findings to the 1995-1999 studies we found some attitudes were much the same but we also found some significant changes. Most notably we found that the perspectives of our students were often more alike than different. In particular the pre-1999 gender divide with men "dreaming in code" and women "computing with a purpose" was blurred. We also saw students whose views of their field had broadened quite dramatically from seeing CS as *programming* to seeing the field reflecting *an exciting range of possibilities*. What was most encouraging was that the self-doubt and the lack of confidence that had previously dominated women's experiences in CS (as chronicled in *Unlocking the Clubhouse*) were gradually being replaced by confidence and enthusiasm. Having said that, as we discuss in the next chapter, our studies have found that men continue to show more confidence than women overall.

Diversity Becomes the Norm: The 2004 Case Study

Two years later, in 2004, our goal was to further understand how cohorts of CS students at Carnegie Mellon perceived their relationship to the field and to investigate the gender similarities theme. Hence, we initiated a follow-up ethnographic, qualitative study. The data collection tools again included face-to-face interviews, online surveys, discussions and observations, with interviews providing the primary data. Indeed, interviews, using an adaptation of the interview questionnaire used in previous years, allowed us to assess change. As in 2002 the interviews were very open ended and meant to solicit perceptions and comments from the undergraduates who participated. Again, we used traditional qualitative processes for the analyses and evaluation of the data.

In the 2004 class there were a total of 156 seniors (52 women and 104 men) and in our case study we interviewed 55 students at length, 32 women and 23 men. All 55 interview transcripts were read and analyzed to arrive at our conclusions. In addition, in order to examine our findings in more detail and to do a gender comparison we focused on a representative cohort of 20 men and 20 women; five of those women were actively involved with the organization *Women@SCS*. As we made comparisons for more intensive analysis we also broke down the cohort into three subgroups, active members of *Women@SCS*, other women, and

men. The analysis involved reading each transcript in its entirety and reading sets of responses to each question. This allowed us to identify and compare prominent themes, common issues, and patterns of perspectives. Whichever way we analyzed the data—comparing men with women, women with active members of *Women@SCS* or men with active members of *Women@SCS*—we did *not* see evidence of a strong gender divide. But, we did find student attitudes had changed considerably since the research of the 1990s; changes which had become the norm for this class. Namely, we found students becoming increasingly proud of their self-image and ready to acknowledge that their academic and social student community was indeed a diverse community in terms of people and personalities.

Findings from surveys contributed to our conclusions. Men and women expressed very similar factors leading to their decision to major in CS, the main one being an interest in computing. They were also very similar in liking the breadth and versatility of CS. We found strong gender similarities in the work ethic with students driven to master challenging problems in CS. Both men and women showed a high motivation to learn the material, which in turn resulted in a higher level of persistence among these students. We were very encouraged to find that the majority of women were reporting feeling increased confidence levels, although more men than women reported feeling high confidence levels. When asked about confidence in specific skills, such as programming abilities, women and men were reporting an almost identical sense of confidence (in fact women were more confident than men although the difference was not significant). Survey findings from sophomores through seniors showed that gender similarities appeared in students' sense of success in the CS program and in feeling they fit in both academically and socially in the CS environment.

Our 2002 and 2004 studies provided evidence of important changes, changes that illustrate that in the post-1999 *more balanced environment*, gender similarities have emerged along with the Women-CS fit. We believe that factors relating to three critical areas of *balance* have provided the crucial impetus for cultural change: (1) improved gender balance; (2) a broader range of student personalities; and (3) enhanced opportunities for women through *Women@SCS*. *Women@SCS* works to ensure that women do not miss out on the kinds of social and professional opportunities, including the mentoring and networking that can go on more readily among the majority male group. The organization has also provided visibility and opportunities for leadership that ensure

women can contribute to the culture of the department together with their male peers. These findings stand in sharp contrast to the gender divide noted in the pre-1999 findings.

Monitoring the Pulse on Diversity: The 2009-2010 Case Study

The 2002 and 2004 case study revealed that Carnegie Mellon had developed a culture and environment in which women felt they *fit* and could contribute to the CS culture alongside their male peers. The motivation for the 2009-2010 study was to determine if, as our observations indicated, it still held true after five years. Ultimately, we aimed: to (1) assess undergraduate attitudes and perceptions towards CS to identify some specific cultural factors that were already contributing to the increased participation of women in CS, and (2) to ask how we could apply this information to improve our strategies for change.

We developed a two-page survey. The questions were both open-ended/qualitative and quantitative in nature in order to elicit a rich set of responses from the participants. Over 35 questions were included on the survey and focused on a variety of constructs: experiences and reasons for choosing to study CS (individual background and high school experiences), experiences in the environment of the Carnegie Mellon Computer Science Department, views of the CS field, career plans, and attitudes to their peers, to classes and to faculty.

The survey was distributed in hard copy to 110 out of 131 total CS first year students and 149 out of 456 total CS upperclass students. We collected 259 survey responses in return. The responses were then manually entered into electronic form. The participants included representatives from all years of study. The sample represents approximately 46% of undergraduate CS males and 52% of undergraduate CS women. Again, we used traditional qualitative processes for the analyses and evaluation of the data.

Our analysis found that most students felt comfortable in the school, believed they could be successful in the CS environment at Carnegie Mellon, and thought they fit in socially and academically. In brief, we did not see any evidence of a strong gender divide in student attitudes towards fitting in or feeling like they could be successful; indeed we found that the Women-CS fit remained strong from prior years.

Diversity in Light of Curriculum Changes: The 2011-2012 Case Study

For the ten years between 2002 and 2012, we paid close attention to the culture of computing and monitoring the Women-CS fit. In 2010, the undergraduate CS curriculum was reengineered to provide a greater emphasis on theoretical thinking in the early curriculum. This change prompted our next study, 2011-2012.

The primary data collection tools for our continued monitoring included interviews (for depth) and a survey (for breadth). Interview and survey questions covered a wide range of topics ranging from background in computing, reasons for choosing the CS major, favorite classes, attitudes towards programming, and many more. CS sophomores (first to experience the new 2010 curriculum as first year students) were invited by email to participate in interviews. We identified and interviewed a cohort of 20 men and 20 women. We also interviewed four students who had switched out of CS. Interviews, which lasted approximately 30-60 minutes, were audio taped, transcribed, and analyzed. Surveys targeting the entire undergraduate student body were conducted in spring 2012. We collected 200 survey responses (52 women and 148 men) from first year through seniors. We again used traditional qualitative and quantitative processes for the analyses and evaluation of the data.

In brief, we found the Women-CS fit at Carnegie Mellon continues to present a positive and encouraging story. Our findings demonstrate that under certain conditions women, alongside their male peers, can fit successfully into a CS environment and help shape that environment and computing culture, for the broader benefit. The case studies also helped us refocus the "problem lens" and to demonstrate why this is a critical step to attracting and retaining more women in the computing discipline. By moving beyond old frameworks that situate the problem as a male-female dichotomy, we are able to employ more sophisticated and robust tools for analysis and interventions.

CHAPTER 5

An Ongoing Journey of Women
in the School of Computer Science

Yeah, I'm definitely a CS major at heart.

– Carnegie Mellon Female Sophomore, Class of 2014

Yes. I am a CS major at heart.

– Carnegie Mellon Male Sophomore, Class of 2014

In this chapter we illustrate some of the major changes in student attitudes towards CS since 1999. We look at the following areas: entering the CS pipeline, perceptions of the field (definitions and interests in CS and attitudes towards programming), challenging stereotypes in CS, perceptions of individual performance and confidence, and the culture of inclusion in the School of Computer Science. We illustrate the shifting landscape with data collected from our cohorts' interviews and surveys from the 2002, 2004, 2009-2010 and 2011-2012 case studies. We have shaped the analysis to allow the voices of student participants to speak for themselves and their comments are often revealed verbatim.

Entering the Computer Science Pipeline

As we investigated the backgrounds of our cohorts from the multiple case studies, we found that in contrast to the 1990s women were just as likely to grow up with a computer in the house as the men and also just as likely to be the primary user. Students (men and women) had similar reasons for choosing the CS major and many came from families who encouraged their daughter or son to pursue her/his interests, and even encouraged their daughter's curiosity to just "play around" with the computer. What *had not changed* was the influence of family as a primary force for exposing students to computing and for providing role models. Most of the women in both the pre-1999 and post-1999 studies came to computing through their interest in math science and "were students who enjoyed problem solving, doing puzzles, exercising logical thinking skills" (Margolis and Fisher, 2002, p. 18).

If our students' backgrounds are in any way typical of CS students across the nation it could have serious ramifications for our efforts to broaden participation in CS, especially when CS is largely absent from the K-12

curriculum. The potential for discovering talent and interest in the field will remain elusive if, for the most part, it is nurtured only among students who come from "computing families." This suggests we need to do a better job of helping *many more* parents and guardians understand what CS is, and why computing studies can benefit their girls and boys especially in terms of potential careers. Changing the perceptions of CS among parents is critical for changing the perceptions of their young students.

The Computing Family

During the interviews of the 2002, 2004, 2009-2010 and 2011-2012 case studies, we asked several questions relating to students' early computing experiences. Most of them recalled having a computer around as they were growing up. Indeed most recalled having one in the house before middle school age. During the 2004 interviews only one woman and one man both said they'd had a computer in the house as long as they could remember. By the 2011-2012 interviews we saw a shift in that the majority of the students felt they *always* had a computer in the home or in their lives. What was consistent between the two time periods is that both men and women claimed to have been the most frequent user of the computer in their household. "Probably me" was a common response when students were asked who used the computer most. One woman shared:

> I grew up with a computer in my house so—I mean I always used to play around with it and I was sort of interested in web design so my parents signed me up for a couple of those classes. I was pretty young then so it was basic HTML.
> – Female Sophomore, Class of 2014

Past research has found that women entering male-dominated fields tend to come from families where both parents are highly educated and success is considered highly critical (e.g., Jackson et al., 1993; Smith 2000; Trauth et al., 2004). Other studies have noted the strong influence of fathers and other male family members in exposing children to computing (e.g., Margolis and Fisher, 2002; Schulte and Knobelsdorf, 2007; Teague, 2002). For instance, a study conducted by Turner et al. (2002) found that among the female information technology professionals in their sample "27% of the fathers held jobs that could be considered technical, with technical being interpreted as jobs in engineering, CS, mathematics, physics or chemistry."

Our findings also reflect existing research regarding the importance of a family that embraces computing. We found during the interviews from the 2004 and 2011-2012 case studies that parents—and in particular father-figures—figured significantly in the background of all students, including women, and their early computing experiences. This was a marked change from the pre-1999 studies when fathers "actively engaged" their sons much more so than their daughters (Margolis and Fisher, 2002, p.25). By the time of our post-1999 case studies fathers proved to be major influences on their daughters. One female student explained that she grew up with a computer in her home and while she could not recall her first experience she was certain it involved playing some sort of game with her father. Several females discussed programming on the computer with their fathers. Others mentioned "figuring things out" on the computer with fathers. For example, one female recalled working with her dad to program an electronic clock with digital basic. Women also spoke often about the positive encouragement and mentoring they had received from their fathers:

> My dad, because he encouraged me. I thought [when I took my first computer programming class], "That's not interesting." He was encouraging. He was like, "Oh, that's a good idea," because he knew that in his line of work, programming was really helpful. And so I think he was pretty supportive of the idea of going into computer science.
> – Female Sophomore, Class of 2014

References to mothers also appear in the comments of female students as they discuss influences and early computing experiences but are typically often absent in the comments of male students. In fact, only two men from the case studies (one from the 2004 interviews and one from the 2011-2012 interviews) were the exception in specifically mentioning their mom's role in influencing their interest in CS.

"Siblings" and "sharing the computer" were frequently mentioned together. Several women and one man saw the computer as a family computer: "Everyone kind of used it for their own thing." What became clear from these students' early memories was that the computer was *not* a boy's toy, tucked away in his bedroom. The women grew up using the machines as frequently as their male siblings and peers. They did not see themselves as watching from "the sidelines," or becoming interested in computing vicariously by watching a father or brother work. The women in our studies were, for the most part active

computer users whose personal initiative sparked their interest in computers and computing. As one woman remarked:

> I actually started programming in Basic when I was really little . . . I used to get magazines and they'd have little code snippets so I'd put those in, try them out on the computer.
> – Female Senior, Class of 2004

The students in the case studies often had another extended family member in the field.[43] Again dads figured largely, and mothers and siblings to a lesser extent. Yet the students frequently discussed the role of family members, and friends in the field (e.g., uncles, cousins, etc.). During the 2011-2012 interviews, only four women, as compared to eight men, mentioned role models or teachers as being an influential person in their decision to pursue a bachelor's degree in CS.

This also ties in with another finding in our case studies, which showed that both men and women were more likely to note a range of people when asked who was most influential in their decision to major in CS, but the order and weight varied between the groups and over time. For example, during the 2004 interviews, women cited fathers, teachers, family, and mothers (in that order) as influencing their decision. Whereas, the men interviewed in 2004 self-identified as their major influence, followed by teachers, dads, and family. This held up for the men in the 2011-2012 interviews, *but also emerged for the women.* Out of the 20 women interviewed, 11 of them pointed to themselves as a major influence by stating, "I did" or "I just decided for myself." For instance, this woman stated:

> My parents are supportive, were supportive of any major I chose, and so I mean in that sense, I guess it would be them. But it was really myself who decided this is what I want to do with my life and pursued it.
> – Female Sophomore, Class of 2014

Initial Interests in Computing

Throughout all of the case studies (2002, 2004, 2009-2010 and 2011-2012), we found students' initial interests in computers and computing ranged from programming to playing games to using applications (graphics, Word, etc.), and combinations of those activities. The word *curiosity* emerged in women's responses, although it is stereotypically

thought to be a more common motivator of men. Some females would discuss building basic websites with HTML to show their comic book drawings or interesting projects. Women would say they became interested by just "playing around," "fiddling around," or just being "curious." For instance, this student commented:

> The second my father took the first computer out of the box. I was interested because I didn't know what it was. . . . I've always been curious about things. When I was younger I used to take things apart to figure out how they worked.
> – Female Senior, Class of 2004

Most students recalled having a computer in the house by their middle school years and home was by far the most significant place for instigating their initial interest in computers and computing. For several students early schooling was critical as one woman who graduated in 2004 mentioned that she first learned Logo—a basic programming language—in kindergarten. She used it to draw pictures and really enjoyed the experience.

Most students were first introduced to formal CS classes in high school (including some programming). Several students shared their multiple experiences with CS classes in middle and high school:

> (W)hen we started getting into more of the programming side, like actually writing a code and stuff, I just really liked it and so I just kept taking more and more classes and I just kept getting more and more into it. I took a normal CS class and then I took the Advanced Placement computer science class. And afterwards, I actually ended up doing an independent study. I built a chess bot. It was fun.
> – Female Sophomore, Class of 2014

The Decision to Major in Computer Science

The majority of the students we interviewed in the case studies, women and men, came into CS initially because of their interest in the field. For some it was a simple decision. For example, one woman coming into CS felt like it was not a decision, just something she was "going to do." This woman highlights a typical response when she explains "it just seemed like a fit," and this man saw it as a "natural follow up" to high school. For others the decision was more complex, but more often than not the

students were already on a math/science track. For some students the career prospects were important. For others the field offered more options than traditional math and science majors. For example, some students shared these thoughts:

> There are so many possibilities with [CS]. It was mostly the fact that it was so versatile that you could include music and art and language and all of it, that I was like, Hmm, I should see what the opportunities are. I've always really liked math, so it seemed like the most right choice I could make.
> – Female Sophomore, Class of 2014

> It's a huge field that has a lot of interesting problems that need to be worked on and pretty much really relies on computer science now, whether it's math or any of the sciences or anything. I think it's still a growing field and a really interesting one.
> – Male Sophomore, Class of 2014

There were few to no gender differences in the reasons students chose to enter the CS major. Cohoon and Aspray (2006) found something very similar "For the most part, the male and female students with whom we spoke felt initially attracted to computing for the same reasons" (p. 218).

Perceptions of the Field

Students' Definitions of Computer Science

One of our goals was to capture students' evolving relationship to CS. Over the course of our case studies, most of the students claimed that when they came to Carnegie Mellon they would have defined CS as programming. This definition and understanding had evolved by their sophomore year. By their senior year, students struggled to define CS after being exposed to both the breadth and the depth of the field through the CS curriculum. Most students would describe CS as the science of computation or the science that "pushes" the boundaries of computation. Many students stated that CS is not just programming. For instance, this male stated:

> It's not programming, computer science is not programming!
> – Male Senior, Class of 2004

Others shared:

> I feel like there are actually many definitions for computer science, so I believe it's the science of understanding and solving problems.
> – Female Sophomore, Class of 2014

> It's really essentially problem solving. [It] is what's emphasized here more than programming is, but it's like an additional thing. I'll always hear people say that if you know how to think, then they can teach you the language and everything. But if you know how to reason and solve puzzles or problems, then that's like what's the most important part.
> – Female Sophomore, Class of 2014

At least two students referred to Edsger Dykstra's quote during the 2004 interviews about computers being a *tool* for CS just like the telescope is a tool for astronomy. Another student managed to capture the ubiquity of the field with an elegant description:

> Too big of a discipline to be defined but a very specific way of approaching problems and dealing with them.
> – Male Senior, Class of 2004

For most students CS had come to mean a challenging and complex field. They described it as: "applicable to everything," it's about "algorithms and [the] theory of computation," "math and other philosophical things," "problem solving," "it's a tool box, a set of tools for being able to reason methodically about all sorts of problems," and "a way of thinking." These are the core aspects of CS that have captured their interest, their intellect, and their enthusiasm. This woman explained:

> I really enjoy like getting a problem and having to figure out a way to best implement a solution. Even debugging, in its own right, is problem solving because you have these crazy bugs and you're like, "How do I find out where these are? How do I fix them?" And it's kind of great, 'cause basically every single aspect of computer science is problem solving to varying degrees and I just get to do that all day and that's amazing.
> – Female Sophomore, Class of 2014

For her, CS is a logic-based system to solve problems. The computer itself and programming were now seen as tools for solving problems

in a structured manner. Students agreed that the way CS was defined in high school: CS means programming—a limited definition which continues to feed the public's misconception—is narrow and misleading, and fails to represent their new appreciation of the field. These perceptions from our students suggest that if the broader concepts of CS could be designed for, and implemented at, the middle and high school levels we may well find that CS would be of interest to a broad range of girls and boys.

Students' Interests in Computer Science

During the case studies, students were asked what interested them most and least about CS. In general, a range of interests and areas were identified across the genders: problem solving (in general or for a problem-space domain), building or creating something, working with useful applications, and long-term opportunities. Given the students definition of CS, it was not surprising to find that so many of them were interested in the field because of the problem-solving factors. Students frequently mentioned their interest in logic, algorithms, solving puzzles and problem solving. For instance, this woman illustrates:

> I really don't think computer science has anything to do with computers. It's more of, here's an interesting problem, here are some ways to solve it.
> – Female Senior, Class of 2004

Students also mentioned that they were interested in working on problems in particular domains (such as robotics, graphics, human computer interaction, etc.). But more often than not students appreciated the breadth of CS. For example, one male suggested that he was interested in CS because of its breadth *and* its applications to so many other fields.

With this opportunity, a few students acknowledge their excitement about making a difference in the world. For example, a few students felt that CS gave them the ability to create something useful that people can use to save them time, or to make doing something easier. Several students appreciate the ability to potential "change the world." They would acknowledge the possibility of using a single program to have great impact. For example, one male said:

> You can start from nothing and end up with something new, amazing, incredible, revolutionary and then with like, with the

press of a button, you can share it with the world.
　　　　　　　　　– Male Sophomore, Class of 2015

Others suggested that the practicality of CS and the ability to solve an abstract idea or algorithm could be applied to the most practical and everyday problems. As the men explained what interested them the most they also showed how applications-oriented many of the men in our case studies tended to be. A man explained:

> What I'm really excited to start doing after I finish the core curriculum is to do electives and look more at the applications of that stuff.
> 　　　　　　　– Male Sophomore, Class of 2014

Similarly, when students were asked about what interested them least, a spectrum of comments emerged. The largest area of *least* interest was theory and math, at similar rates for both men and women in both 2004 and 2011-2012.

This student explained:

> I see proofs sometimes that don't have application and I don't see a point. It's just like, yes, it's nice to exercise the act of proving things. But, ah, if there's no point, then don't do it.
> 　　　　　　　– Male Senior, Class of 2004

Attitudes to Programming

When we looked at attitudes to programming in the 2002, 2004 and 2011-2012 case studies, we found one of the strongest illustrations of emerging gender similarities. In answer to the question, "Do you like or dislike programming?" the responses revealed the majority of students liked, and in many cases even "loved" programming. Cohoon and Aspray (2006) made a similar observation when they looked at what had initially attracted students to CS: both men and women enjoy programming. Many explained that programming is "awesome" and that getting something to work is "really great." In our interviews, several women explained their attachment to coding:

> I like programming. I guess it's also this kind of instant gratification feeling again where if you can code something and then just clicking that one button and seeing it actually happen right there

it just kind of okay wow I got that to [work] . . . the feedback that you get that quickly is what I like about it. And then there's all this problem solving skill that you have to go through, and if you can do that yourself and by coding it you prove to yourself that you could do it, that you could solve the problem. I think that's what I like about it.

– Female Senior, Class of 2004

This man showed a similar attachment:

I love programming, very much. In programming you are limited by the time you spend, not the computer. And, so I like that sort of fast feedback and being able to see things immediately.

– Male Senior, Class of 2004

During the 2011-2012 interviews, the responses ranged from expressing the sense of accomplishment that programming can provide to the creative side of programming. The majority of students said they loved or liked programming. In this cohort 16 out of 20 women and 13 out of 20 men reported these sentiments. A male expressed that it is "amazing" to do so much with just writing code. A female was excited that you could "create so many things" with just programming.

Initially, we sorted the responses into two main categories, "love or like" and "dislike," but it soon became clear that this was an oversimplification; indeed it was quite obvious that a third category had emerged, a category in which the responses were "mixed," showing the limitations of a simple oppositional yes/no answer. Gender similarities, rather than differences, emerged again with students providing thoughtful responses as they tried to explain their views. Common responses were along the lines of "a little bit of both," and "I have to say I'm kind of in the middle." One student felt that she liked the higher-level programming, but disliked the systems level programming and felt it was a "mixed bag." Another student qualified his feelings about programming:

I think, generally, I dislike it. Unless I know exactly what the code's doing, which is rarely the case. And if it's something I'm interested in because, like I said, I wouldn't want to just write code for the sake of code, I want it to be able to do something noticeable.

– Male Sophomore, Class of 2014

Answers to the question of liking or disliking programming revealed a spectrum of attitudes which cut across gender and many students qualified their attitudes. Thus, liking and/or disliking programming was determined by a variety of factors, primarily what kind of programming was involved, what the purpose of the programming was, and the number of hours spent actually programming. While most students in this cohort, said they liked programming, or had mixed responses, most did not see themselves with future careers focused solely on programming. Several felt that they might get bored if they were asked to program for many hours a week for the rest of their life. As one woman put it:

> I enjoy programming. I really like it. I guess I don't really enjoy it on a daily basis, for example if I had to do it 50 hours a week I don't think I would enjoy myself.
> – Female Senior, Class of 2004

Challenging the Stereotypes

Stereotypes impact us all; they are entrenched in the cultural images that surround us. The media (movies, television, Internet, comics, etc.) help us to develop and maintain stereotypes through the types of images and levels of (mis)representation they produce (Matlin, 1999). CS stereotypes, for example, act as shortcuts for *what we think we know* about CS and about the people in the field. The "geek" stereotype—the image of the (white, male) computer obsessed intelligent individual who has poor social skills, and pays little attention to hygiene and appearance— is pervasive and potentially harmful in deterring some young students, especially girls and women, from considering the field. Some researchers have seen the geek stereotype, even though something of a myth, as a major source of gender difference having a *"differential impact on male and female students"* such that *"women enter the field in smaller numbers than men, and are more likely to leave"* (Margolis et al., n.d.).

With all this in mind, as we listened to Carnegie Mellon students discuss CS stereotypes, we were surprised and fascinated to see them constantly redefining and reshaping the images of CS that surround them. They show that stereotypes, a seemingly impenetrable obstacle to broadening participation in computing, can be changed.

Characteristics of Computer Science Students at Carnegie Mellon University

In the 2002, 2004, 2009-2010, and 2011-2012 case studies, we gave students an opportunity to give their own perspectives on their peers. We asked students the question "Can you describe the characteristics of CS students here at Carnegie Mellon?" Among the student responses some words and phrases were heard repeatedly: "intelligent," "creative," "hard working," "passionate," "focused," "smart," and "diverse." The range of descriptions included: students are well rounded, involved in activities outside of computing, and generally not conforming to the CS stereotype.

By 2002, students were already commenting on the diversity of student characteristics:

> There isn't a typical student any more. There are some traits that you have to have. They have to know how to use computers, but there is such a range of students.
> – Male Senior, Class of 2002

Many similar observations appeared in the interviews across many years. Students felt that there was a huge range of people who actually like CS. In the words of these students:

> I guess I can't specify one thing because I think everyone is different so I can't really pinpoint certain characteristics from one computer science major to another.
> – Female Senior, Class of 2004

> CS majors are diverse. CMU CS majors are smart and good at computer science, and beyond that there is nothing that they all certainly have in common, and no stereotype that would be fair.
> –Male Senior, Class of 2010

The most common indication of diversity took the form of students struggling to answer the question with specifics. A few students replied that we are "all different" or a "wide range of different people" or "surprisingly" a diverse crowd. Despite this diversity, many remarked that most CS students share a hard-working mentality and the ability to take on challenges.

A view that was repeated by many respondents was that even though some students fit the geeky stereotype, they were just one group among

diverse groups of personalities and interests. This woman made a fitting remark:

> Computer Science stereotypically has a lot of really nerdy, weird people, and people who don't shower or something and they don't talk to anyone. I haven't met anyone who is like that.
> – Female Sophomore, Class of 2014

This woman felt that CS at Carnegie Mellon was special in the way students were allowed to explore a breadth of interests. As she described how important this was for her she also noted the broader understanding of diversity that characterizes the School of Computer Science:

> I do remember though, when I was visiting schools before I decided on Carnegie Mellon, I did get a sense from other schools that they were not as open to diversity maybe. And I don't mean diversity in terms of minorities and women, but I mean in diversity of interests. I remember visiting I think it was the [other school][44] and their computer science department felt so rigid and technical and that's not at all what I wanted. I wanted it to be more open and allow me to try interdisciplinary work and stuff.
> – Female Senior, Class of 2004

We found that the most common viewpoint expressed by the cohorts was that the community was made up of three different sub-groups: those students who were totally into computing, those who preferred outside activities, and those who occupied the middle ground. The next most common characteristic perceived by the cohort was that the student body was "diverse." Another characteristic noted was "hard working." Several of these characteristics were noted fairly equally by both women and men. One woman who identified three sub-groups also noticed interesting changes in the student body:

> It seems like the people who saw CS as something they're studying and not like a way of life. I see more and more of those with every incoming first year class. And the other type it seems like in high school they weren't the most social people so they're learning to be social as well as learning computer science at Carnegie Mellon. And the other people are more formed, whole people when they come in.
> – Female Senior, Class of 2004

In addition to the student's assessments of their peers, interviews with faculty members helped broaden our understanding of CS students. Faculty also noted that there is no one template for a computer scientist at Carnegie Mellon, echoing the student's own perceptions of themselves and their peers as a diverse bunch. Several faculty members mentioned that while there was no "typical" CS student any more, for students to be successful in CS they needed to have some specific skills in common: a strong work ethic and a strong sense of self, enabling them to ensure a balance of work and other interests. One faculty member pointed out that these skills were expected campus wide, reflecting Carnegie Mellon's criteria for success, not skills confined to the Computer Science Department. Students in our cohorts also linked the CS work ethic to a university wide characteristic.

Not the Traditional "Geek"

By 2002, changes in the student body were affecting the culture of computing at Carnegie Mellon such that the familiar "geek" culture, reflecting the larger computing culture, was losing the dominance it once had. Perhaps one of the most obvious indications of this evolving culture was the way in which CS students were redefining their own self-images and the images of their peers.

The 2002 findings suggested that our students were moving towards a new identity with respect to CS based on a well-rounded image, which challenged the traditional CS stereotype. This finding held true in the subsequent case studies of 2004, 2009-2010 and 2011-2012. For example, we saw strong challenges to the image of "dreaming in code" (Margolis and Fisher, 2002, p. 5) as representing the male CS student's attitude towards computing. Men seemed just as likely as women to appreciate computer applications and want more from the field than programming. We found men who were as socially outgoing as women, and women who could be just as "geeky" as men. Although no interview question category specifically addressed the issue of stereotypes, all eleven of our categories had questions that elicited responses related to CS gender stereotypes. We were struck by how frequently the seniors' responses did not fit traditional patterns. This woman voiced the same perception:

> Some [women] were just as hard-core as the guys. And the guys, it's the same thing, some of them really want to spend all their time on the computer and not think about anything else, and

some of them are really not like that, and [are] really interested in making it more appealing.
– Female Senior, Class of 2002

The picture of a narrowly focused CS student did not emerge. To the contrary, we found students with a variety of interests and with social circles both inside and outside of CS: students who were involved in outreach activities and community service, students who enjoyed both humanities and science classes, and students who were aware of the old "hacker" stereotypes and determined not to be like that. Our cohort included students who played the violin, wrote fiction, sang in a rock band, participated in team sports, enjoyed the arts, and were members of a wide range of campus organizations. We found that most students appeared to be moving towards a more well rounded identity that embraced academic interests and a life outside of computing. Students described themselves as "individual and creative, just interesting all around people," "very intelligent," very grounded, not the traditional geek," and "much more well-rounded than people five or six years ago."

This is not to say that students who enjoyed coding did not exist, nor that programming wasn't still an important part of their world, it certainly was as we explained earlier. But this interest seemed to be placed within a broader context, with respect both to the field of study as well as participants. We found students who enjoyed programming and the "geekier" aspects of CS, and we found students who did not.

In the 2002 case study, the longest interview and seemingly most sociably outgoing student in the cohort was a young man who talked for over one and a half hours, while the "geekiest" of students interviewed was a woman who recalled that as a child she had kissed the computer in much the same way as she would kiss a fond toy. This student had originally "wanted to fit the stereotype" but finally adopted a more self-assured attitude as she claimed some aspects of the geek stereotype, while maintaining a feminine identity, "You know a girl can be good looking and still be in computer science and still be smart goddamn it."

In his paper "Race, Sex and Nerds: from Black Geeks to Asian-American Hipsters" Ronald Eglash (2002) talks about the "normative gatekeeper" as he examines the relationships of race and gender to the figure of the nerd or geek. He concludes that it's not easy for blacks or women to simply *adopt* the geek identity, because the geek image acts as a "normative gatekeeper," but rather they need to invent a new identity.

What seems clear is that these students were constructing a new image of the CS student. We might speculate that the culture in which they spent more than three years of their studies, a culture with an increasingly diverse student body *and* which supported this diversity, had shaped their image of themselves with respect to CS. We might speculate that the changing culture gave permission for men to explore their non-geeky characteristics and women the encouragement to be both feminine and computer focused. For the most part, our cohort seemed to be identifying with the more diverse aspects of the student body while retaining some of the traditional aspects. For instance, one woman stated:

> Everyone's a geek and they know it and they're very proud of it. . . . People aren't afraid to do what they want to do, and I feel like if you had an interest in any aspect of computer science, you'd be able to find people in the community that are also interested.
> – Female Sophomore, Class of 2014

Overall, findings in 2002 showed that women seemed to be constructing a new identity that was both "geeky" and feminine. At the same time many students in the cohort were reevaluating and redefining what it meant to be a computer scientist. When we conducted the follow-up interviews in 2004 and 2011-2012, we found this new identity had evolved yet further as students broke with old stereotypes, claiming the "good" aspects of geekiness, respecting diversity, and ensuring they maintained broad and balanced lifestyles.

This woman summed up what so many others voiced:

> I've been surprised by the number of cases where people who are computer science students but put a lot more effort into studying artistic endeavors, or studying a language, things like that. I know there's the common stereotype of people who don't get out very often, [who] sit in front of a computer. But I think if you look around enough, that's not really what most computer science majors are doing with their lives.
> – Female Sophomore, Class of 2014

Breaking with, and Living with, Stereotypes

In the 2002, 2004, 2009-2010 and 2011-2012 case studies, we found consistent responses to questions about the stereotyping of CS and computer scientists in the dominant culture of the United States. Not

surprisingly, we heard familiar comments from students confirming they knew only too well which stereotypes persist in the broader, popular culture: a computer scientist sits in front of the computer all day programming, is odd looking, unhygienic, nerdy, and anti-social.

In our 2002 cohort, students were most likely to argue that "this is not me," confirming the notion of a "geek mythology" found in the pre-1999 interviews (Margolis et al., 1999). At this time many students distanced themselves from the traditional stereotypes. "[The geeks] give a bad rap for everybody else," remarked one young man.

In later cohorts, however, several students appeared to be quite happy to have some connection to CS stereotypes (or part of them). They explained that CS might be "nerdy" but it shouldn't carry a negative connotation. For example, this woman shared:

> Everyone's a geek and they know it and they're very proud of it.
> – Female Sophomore, Class of 2014

While some students made a point of noting that the stereotype referred to men only, some women appeared to include themselves as part of the stereotyped community. One woman even exclaimed, "We're all geeks." Another shared:

> Nerdy jokes, making jokes about Linux and things like that and I see no problem with that. I think it's funny too. I think that the stereotypes aren't malicious. I think that they are fine. To a certain extent I think that people embrace them here and that's fine. I think that people don't mind. They know that this is what they are like and they're not going to hide it and I like that a lot.
> – Female Senior, Class of 2004

Several women suggested that nerdy characteristics could also be applied to Carnegie Mellon students in general. One female felt that the nerd quality applied to all Carnegie Mellon students at the university in some aspect. She felt that CS is a "big bunch" of nerds, but that was the case with the entire university student body. One woman explained the range of student interests from technical to artistic, pointing out the only thing they all have in common is that they all happen to "write code."

For the most part, students in our later cohorts suggested that stereotypes had not impacted their experiences in any significantly harmful way.

They did not appear threatened by the dominant CS stereotypes outside of their domain. Rather, they felt comfortable with themselves, their peers, and the images surrounding them.

Another stereotype surrounding CS students is their supposed 24/7 attachment, by choice, to the computer. Contrary to this we found that students really wanted to try to have a balanced life and include extracurricular activities in their schedules even though time was often a challenge.

Several students pointed out that time spent "obsessively connected" to the computer was actually tied very closely to times when homework and lab projects were due. At that time they agreed that (as this woman noted) "all you can do is your project," and (as this man noted) "social life is completely disrupted by the fact that they have to go sit in the cluster for twelve hours and work on something." Hence, time management becomes a very important skill for these students but the stereotype that they "just sit in front of the computer all day" was clearly not true. For many of the students there seemed to be a shift in the definition "geekiness." It now referred to the amount of *time* spent at the computer versus other stereotypical features—looks and anti-social characteristics were not mentioned nearly as much, while time issues cropped up in many answers.

Furthermore, as these student explained, when time spent working became intense, the group work effort could be fun and play a role in community building. Students spoke about working on big projects in the computer clusters and described that a "ton" of people would be working together until midnight. Many felt that the projects were "common enemies" and everyone would get along and laugh around while working. Two students explained:

> I got the impression, you know, when I'm sitting in the cluster at like, you know, two o'clock in the morning and I can't [laugh] I can't get this thing to work or whatever, you know, the people around me who are stuck there too are like, you can see those problem is difficult for them there um, they wouldn't rather be doing anything else.
> – Female Senior, Class of 2004

> There's kind of a camaraderie that builds up there and then other social circles begin to become neglected in some sense. The real

friends that a student like this will make will be the people that they're working alongside. And then that seems antisocial from the outside.
– Male Senior, Class of 2004

In our *post-1999* case studies we did not see stereotypes contributing to a gender divide as noted in the early research of the 1990s. Instead we found most students showing a spectrum of attitudes and interests in computing and old stereotypes were giving way to new identities, rich in breadth and diversity. And, when students drew on aspects of traditional CS stereotypes, these often became a source of common ground for men and women rather than a source of gender divide.

Perceptions of Individual Performance

Confidence and Programming Skills

When asked if they had the skills for good programming,[45] women and men similarly reported requiring certain skills: you have to be well-organized and able to think ahead; you need good problem-solving skills; you need to be able to think logically and analytically and have lots of patience. During the 2004 case study, women were a little ahead of men in showing confidence in rating their programming skills. This woman illustrated the confidence she felt in her programming skills and some surprise at the question: "As you get more exposure to programming it's impossible not to develop these skills."

Another women shared:

> It's always fun to sit down in front of a computer and kind of producing code until something is done and it's such a good feeling. A lot of time once I sit down and do programming I find myself living in the cluster for a day without eating or sleeping.
> – Female Senior, Class of 2004

Once again, an interesting category emerged as we tried to understand the complexity of students' answers. This category, which we called "Yes, But/Doubts," covered a range of attitudes in which students either qualified their sense of having good skills with comments like "yes, to an extent," or expressed some doubts saying such things as "I did at some point." Again strong gender similarities emerged in all categories. These

findings showed great similarities in the way our student cohort was relating to CS, and particularly with respect to programming. It is particularly interesting that when asked about specific skills, and not about *confidence* levels per se, women expressed a sense of confidence similar to their male peers.

Confidence Levels

In all of our case studies (2002, 2004, 2009-2010 and 2011-2012), we found that men consistently report higher confidence levels than women. We speculate that since women have been subjected to the broad American cultural message that women's self-esteem and confidence are lower than men's (Kay and Shipman, 2014; Sandberg, 2013), generally it is perceived that it is less gender appropriate for women to express a sense of confidence than it is for men.[46] As other researchers have found, many women often downplay their abilities (e.g., Dunning et al., 2003; Joshi et al., 2010; Kay and Shipman, 2014). Not surprisingly when we examined the grades overall we found that women were as academically proficient as the men. Our students' attitudes, while shaped by the micro-culture of the department, are not isolated from broader, prevailing cultural messages. This is not to say expressions of confidence were categorically absent. For example, one woman remarked "I see myself as one of best of the best now."

Students stated that although their confidence increased overall, levels varied greatly over the years, depending on the classes they were taking. In addition, as we mentioned, when asked about specific CS skills, women appear to be equally as confident as men in claiming them. Several students said their confidence had fluctuated or remained stable. A few described that they were pretty confident coming into the program and have experienced "ups and downs." Others described a few "bumps along the road" or feeling slightly "subpar." Or as these women said it can do both:

> It's up and down. Last year first semester it was like I was hit by a bus. I was like, "Oh my God, I can't do this." But now I think it's steady. It's like, "Okay, I think I can do this."
> – Female sophomore, Class of 2014

> Once you start working on different projects or having more projects under your belt you just feel a little better . . . public speaking and having a more professional front is all part of it. And

joining a group like *Women@SCS* really helps because there are plenty of chances to speak, talk and I think just growing more as an individual.

 – Female Senior, Class of 2004

The confidence gap has narrowed significantly since the pre-1999 studies were carried out, when some women's confidence was noted as being "extinguished" as they progressed through the program. Nor did we see "drops in confidence precede drops in interest" leading to women leaving the CS major (Margolis and Fisher, 2002, p.5).[47]

Studies have found that students' confidence has direct effects on their likeliness to challenge themselves in courses, research, and graduate education (e.g., Barker and Garvin-Doxas, 2004; Beyer et al., 2002; Irani, 2004). Not all responses showed such a strong gender similarity. For instance, in the 2009-2010 survey results, we found that indeed women were twice as likely as men to strongly agree with the statement: "I feel like everyone I know performs better than I do." Specifically, over 50% of women felt their peers performed better than them, as compared to only 30% of the males. The interview data from the 2011-2012 also supported these findings. Many of the male students shared experiences like "I can keep up with classes," "I do well enough" or "I seem to be keeping up." Whereas, some female students expressed insecurities, "[Carnegie Mellon] is a very competitive school, sometimes it's hard to keep up."

We investigated the confidence levels in more depth among the survey results from 2009-2010 and 2011-2012. We examined confidence levels among the first year cohort in the studies and made a comparison to the survey responses to the sophomore, junior and senior cohorts. And when we looked at the first year students and the upperclass students separately we found similar improvements in their perceptions of performance. By the time students reached sophomore through senior levels their confidence levels improved. In general the responses indicated a positive shift for the women as they gain in experience and receive more feedback about their own performance and the performance of their peers. But overall, as other studies have shown[48] men were still far more likely to admit to higher confidence levels than the women.

A Culture of Inclusion in the School of Computer Science

Sense of Fitting In

In the case studies post-1999, we have consistently found that women were feeling comfortable in the CS community and fitting in with their peers. Even those students who described themselves as not CS focused could find a place for themselves among like-minded allies. Many women felt that there was a "huge spectrum" and "range" of people. Others remarked that the student body had become "much more multi-dimensional." Several students' observations clearly meshed with our own observations about a positive sense of fitting in. One woman described that she "felt like I fit from the start." Others simply stated, "I found my group" and "people like the same things I do." One female put it quite simply:

> I used to not fit in until I came here.
> – Female First Year Student, Class of 2013

During the interviews, students were asked to describe a typical CS student and then where they fit in, or did not fit in, with the self-described picture. For the characteristics some students mentioned seeing sets of characteristics—ranging from those belonging to students who were very CS focused, closer to the traditional CS stereotype, and those who were more into "a bunch of varied interests." Other students mentioned a range of characteristics belonging to a range of students.

The results for this question showed a strong gender similarity among students voicing a sense of fitting in at some level. One student felt that she had a CS "kind of personality" that she was able to make CS jokes with her friends and be accepted for doing so. For some the fit was unquestionable. Many students explained how they have a sense of fit in both academic and social aspects of the community:

> I'm a nerd, but I'm social. There are several people here like that.
> – Male First Year Student, Class of 2013

By far the largest group contained those students who fell into the "mostly" category. By this we refer to the group who, for the most part, saw the CS community as diverse; made up of several groups with specific characteristics, embracing people with outside interests, and people who had friends in other majors. Students felt they had found their place

within one, or more, of the different groups who shared their characteristics and interests.

> There's lots of people with lots of different interests and backgrounds and stuff like that so I yea I think there's other people with the same background as me. I think I fit in as well as anyone else anyway.
> – Female Senior, Class of 2004

A few students made negative comments about fitting in. Among those who felt they did not fit in one woman commented that she felt people were not generally very helpful, while another woman retained her interest and ability in CS but had moved towards Art taking her CS interests with her. One woman said she felt "intimidated" at times by other students, "I didn't feel like I knew as much as they did." Interestingly, this woman had come into the program with a good background in programming. She "really liked the programming courses in high school and I felt that I was good at them." In contrast one woman who came in with no background had found her niche among a group of women she called the "CS chicks." She clearly felt at home during the early introduction classes with "this group of 30 girls and we were all fairly clueless." The two men who did not feel like they fit in commented on social aspects, one finding the other students "immature" and the other wanting more social diversity.

Given the earlier findings about stereotypes and the sense of inclusion in the culture of the school, for the 2009-2010 and 2011-2012 case studies we chose to focus further on the notion of "fit." We included questions about this in both the surveys and interview guide. In exploring these topics we examined the notion of fit from two perspectives—social fit and academic fit.

The need for social belonging, or for seeing oneself as socially connected, is a basic human motivation (e.g., Baumeister and Leary, 1995; Walton and Cohen, 2007). Indeed, a sense of social connectedness can predict favorable outcomes such as intellectual achievement, feeling respected, and compliance with authority figures. Social fit becomes especially critical when students' self-perceptions of their academic performance are inaccurate as we have seen with women who underestimate their ability (e.g., Dunning et al., 2003; Joshi et al., 2010; Kay and Shipman, 2014;). Thus it is vital that departments help "create a sense of belonging that can reinforce student self-efficacy and connections to

community that support student perceptions of their ability within the field" (Veilleux et al., 2013, p. 69).

During the 2009-2010 interviews and as a part of the surveys, students were asked if they felt they fit in socially. Most students in our studies' cohort felt like they had a good social fit. The positive comments from students on their social fit often related to having "lots of friends" and conversely the negative comments related to having "no friends." However, the most common responses were about finding "people like me," people with "similar mindsets" and "similar interests." Once again, the responses were highly positive and produced striking gender similarities even to the point of the language they used:

> Yeah, I'm definitely a CS major at heart.
> – Female Sophomore, Class of 2014

> Yes. I am a CS major at heart.
> – Male Sophomore, Class of 2014

Researchers also explain that perceptions of academic fit are important considerations in students' decision to pursue or remain in a CS degree program. Further, a lack of perceived fit may lead to decreased performance, increased attrition rates and lack of identification with the field (e.g., Beyer et al., 2004, 2003; Cheryan et al., 2009; Steele, 1997). During the 2009-2010 and 2011-2012 interviews and as a part of the surveys, students were asked if they felt they fit in academically. Although fewer women than men agreed or strongly agreed with the statement we still found that most women felt they had a good academic fit. We found that a small percentage of women felt unsure about their academic fit. For example, a few women explained that they feel smart sometimes but "dumb" at other times. One female junior showed that this perception had not dampened her sense of humor: "I sometimes feel like I don't know as much as others, but then I meet others."

Several students commented that the CS major is "hard, demanding." We found a strong gender similarity in such comments: one first year student female said, "It's hard but mostly doable," while a male first year student said, "It's hard but I can handle it." During the 2011-2012 interviews, we saw gender similarities also in the way students expressed their sense of academic struggle wondering if they were up to par but also recognizing that others were thinking the same way.

These findings indicate a marked change from the earlier environment at Carnegie Mellon where the "majority of women struggle to find a place where they can feel comfortable in the prevailing culture" (Margolis and Fisher, 2002, p. 102). Indeed, the early studies showed that in the pre-1999 atmosphere, women did not feel comfortable, academically or socially, while male students were found to have great camaraderie and, by virtue of their programming strengths, could perform well academically.

Thoughts on Switching out of the Computer Science Major

Perhaps inevitably in a challenging program of study, many students think about the possibility of switching into another major. During the 2004 and 2011-2012 case study interviews, students were asked if they had ever considered switching out of the major. On the one hand, most of the students did not share experiences where they considered this option. In fact, there were many students who said they had never thought about switching out. Some felt they would never switch out because there is nothing else they would want to "switch into." For instance, a student remarked:

> I would say that I've never really thought of switching out because I can't really think of any programs that I would be more interested in.
> – Male Senior, Class of 2004

On the other hand, a number of students did express thoughts about switching out of the CS major. For instance, during the 2004 interviews, fifteen women and eight men expressed sentiments about switching out of the major. However, ten of these women and six of the men claimed they had not been really serious about it. Over time the numbers shifted and during the 2011-2012 interviews men outnumbered women with eleven men and ten women expressing sentiments about switching out of the major!

The overwhelming reason for thinking about switching out was academic, sometimes relating to a particular course, or timeframe, as this woman explains:

> I remember sitting in a particularly boring 213 lecture and I wasn't seriously thinking about this, but the thought crossed my mind, "If I was math major, I wouldn't have to take this."

[Laughs] And I was like, "This is not good. I need to adopt a new attitude about this class."
– Female Sophomore, Class of 2014

This man similarly doubted his interest and ability:

I looked around me and I saw people that seemed a lot more interested in computer science than I was. Then I got worried that maybe it's not right for me. I wasn't doing badly in anything but I just felt, maybe I should have studied English somewhere, government or whatever.
– Male Senior, Class of 2004

For many students thoughts of switching out were fairly fleeting. Some suggested that they considered it "briefly" but never "seriously." Given that several of the women had considered switching out but had not, it was interesting to learn what kept them going. The primary reason was the challenge, "the challenge is part of the fun," and the decision to "stick with it." This woman expressed it as a kind of "stubbornness," she "wanted to prove to myself that I can do it no matter how much behind I was when I started out." While it seems that the women might have taken longer than the men to recognize that they could be successful in CS, once given the opportunity to be in the CS major at Carnegie Mellon, they were determined to see it through. Many of the same women who had had thoughts of switching eventually felt a tremendous sense of accomplishment as seniors:

Basically, once I finish this school, all the doors will be opened for me, and it's just... it's a pain, you know, at some points, and some classes I don't like, but overall, I mean, it's such a great experience, and it's just something that if you get the opportunity to do you just have to do it. There's no looking back.
– Female Senior, Class of 2004

All of the students in our cohorts did eventually graduate, but of course graduation is not a given. At Carnegie Mellon, on average, more women than men come into the CS major with little to no background in CS. Given that, it's not surprising that some find it isn't a good fit subject-wise and transfer to other majors. Meanwhile, others are thrilled to find that CS is a perfect fit. Among the few students we interviewed or spoke with by email who had actually switched two mentioned they felt uncomfortable socially, but most switched out for academic reasons; in

fact a couple said they preferred the atmosphere in the School of Computer Science to that in their new department.

Research shows that women leave the sciences, including CS and other non-traditional fields for women, in greater numbers than men (e.g., Cohoon and Aspray, 2006; Seymour and Hewitt, 1997). We suggest that thoughts on switching out might not be so fleeting in a less diverse and less supportive environment. Our cohorts fit well and held positive views about the Computer Science Department at Carnegie Mellon and its networks and programs. We might speculate that without this environment, some women students in our cohort (and some men) would have left the major. Indeed, in the pre-1999 environment at Carnegie Mellon women left the CS major at twice the rate of their male peers.

Balancing Computer Science and Other Activities

One of the interview questions specifically addressed the question of work/play/life balance. Students were asked: "Have you felt any problems with mixing CS and the rest of your life?" We were particularly interested to see if women were the ones who wanted more outside-CS activities. The responses fell into three categories: those who had problems, those who had none, and (the largest category) those who ultimately felt they had worked out some balance (time management). Gender similarities were quite striking. Of the students who had problems balancing academic and outside interests, both women and men expressed a similar sense of regret at not having done things they wanted to do. This man felt he had focused too much on CS work:

> There were opportunities to get out and socialize and see different things that I really missed because I was just focused.
> – Male Senior, Class of 2004

Many students expressed similar regrets, sharing that there were things they had to give up in order to finish the major. Others felt reluctant to give up personal interests, but in the end were more concerned with "passing my course." The women and men who had no problems balancing work and "life" seemed very confident in their responses as evidenced by this woman's comment on balance issues, "No, not at all!"

By far the largest group of students felt they had to work at time management but had eventually succeeded in mixing CS and outside activities. For the most part, this group accepted that at times the workload

would be heavy such as when projects were due and lab time increased. These woman's comments exemplified many responses:

> I think it's all in time management I guess. But yeah, I never had a problem with doing CS and living life. I guess there are times when you have to give up a weekend or two and spend all weekend in the cluster but otherwise overall no.[49]
> – Female Senior, Class of 2004

> Yes, it's been fine. It's okay. Obviously sometimes I have to stay in and be like, "I have a test," but it's not I'm miserable here and dying under the pressure.
> – Female Sophomore, Class of 2014

The majority of women and men in our cohort were ready to forego extracurricular activities when workload demands were high, but by managing their time effectively they could still lead a balanced academic and social life.

Student responses to this question stand in sharp contrast to the early research which suggested that women would be less likely to thrive in an environment where a heavy course load limited their social life (Margolis and Fisher, 2002, pp. 61-75). In a 2006 intensive national study examining the retention rates of undergraduate women in computing, Cohoon and Aspray (2006), reported findings similar to our own that contradicted past hypotheses:

> Based on reports of students leaving STEM majors because they required too much work or too narrow a focus (Seymour and Hewitt, 1997), we had expected women to be disadvantaged in departments where faculty both expected many hours of homework per week and believed that student success required limiting extracurricular activities. Neither of these expectations were met; instead, women were retained at relatively higher rates in these departments (Cohoon and Aspray, 2006, p. 225).

We found no evidence to suggest that men in CS were not outgoing, or not especially interested in activities outside of CS. Indeed most of the men in our representative cohort made it clear that they wanted to balance school life with opportunities to explore their outside interests; this man claimed "in everything I do I look for the social side." Another man

illustrated the point that time has been the factor affecting his activities, not lack of interest:

> I do a lot of things outside of CS. Like for example right now I'm writing for Tartan [student newspaper]. . . . I'm a peer tutor, but there's always more I wanted to do. I wish I could've maybe taken a class in CFA or something when I was here. You know, like there's always lots of things I want to learn about, there are lots of things I want to be involved in and I don't have time to do all that.
> – Male Senior, Class of 2004

Student Impressions of the Computer Science Department Atmosphere

When we asked students to describe the atmosphere in the Computer Science Department many came up with very straightforward positive comments saying such things as "pretty friendly, pretty relaxed," "social," "supportive," "very cooperative," "helpful." Several remarked that the student body cooperates and helps each other a lot with the work and "other stuff too." These students stressed the sense of community explaining:

> We all try to help each other out both educationally, emotionally and so on and so forth.
> – Male Senior, Class of 2004

> I think it's collaborative a lot. I've heard of other colleges having a cutthroat environment and people don't ask other people for help or anything. But I think here it's like strongly emphasized that you work together.
> – Female Sophomore, Class of 2014

Students also commented on the hard working atmosphere, identified the atmosphere as friendly and comfortable, and to a lesser extent felt the atmosphere was stressful or too competitive. Several students suggested that the atmosphere was self-competitive. One woman, for example, felt that any competition is always with oneself trying to be better. Many of the students noted the competitive environment as being one that was still collaborative. Even when they commented on competition they suggested it was a healthy kind of competition. As one woman mentioned:

"It's not cutthroat tech like other schools. Here, we're all just in it for the love of it." This woman also noted, "It's competitive in that you want to do well, but, it's a collaborative environment."
– Female Sophomore, Class of 2014

Men also categorized the environment as "collaborative and helpful." Several students used very positive descriptions in response to this question using words like love, enjoy, fun, great, cool, and amazing.

A small number of students made negative or non-committal comments. One woman who was negative/non-committal said she felt "peripheral" to the department, while one man said he found the atmosphere very competitive, but he also said it was "stimulating," suggesting that competitive might not be so negative from his point of view. A few students fell into a mixed response category making both positive and negative comments about the atmosphere.

Since we propose that factors relating to culture and environment play a major role in determining a Women-CS fit, we were particularly interested in the responses relating to specific questions about the environment at Carnegie Mellon. To gain insight into how students felt about the environment at Carnegie Mellon, during the 2011-2012 surveys, we asked them to respond to this comment: "The environment at Carnegie Mellon provides me with everything I need to succeed." We received very positive responses with 90% of the women and 78% of the men in our cohort either strongly agreeing or agreeing with the comment. Significantly fewer men and women responded with unsure, disagree, or strongly disagree with 10% of the women and 22% of the men. These results show that women, slightly more than men, are confident about the environment of Carnegie Mellon providing the necessary resources for success.

Students were also asked if they found their CS advisors and professors approachable. We believed answers to this question would provide another indication of whether or not we were sustaining a good environment. The responses from the 2009-2010 and 2011-2012 case studies were overwhelmingly positive most students saying yes. One male said:

Everybody is approachable. You can send the professor an email or go talk to him after class, and it's awesome.
– Male sophomore, Class of 2014

Another woman compared CS faculty to other faculty and felt that the CS professors were more approachable than other professors. No students gave completely negative replies in the interviews or surveys when asked about the approachability of advisors and professors. We were very pleased to see how well faculty were contributing to an atmosphere in which all students could find help when needed and work towards success. Once again we were struck by the gender similarities in the predominantly positive responses. Carnegie Mellon's Computer Science Department provides an example of the "locally supportive environments" that Cohoon and Aspray (2006) found played a major role in the retention of women. Our findings provide further evidence of a good academic and social fit for most students in our cohort and we see the influence of culture and environment on students' sense of fitting in.

Being a Woman in Computer Science at Carnegie Mellon University

The absence of comments on gender related issues offers some indication of what the environment is like for women in CS at Carnegie Mellon. For example, when students were given open-ended questions, such as "What was the best thing about doing this major?" or "What was the worst thing about doing this major?" gender difference or gender discrimination issues did not show up. Gender similarities, however, did emerge. For example, women and men pointed to the heavy workload as one of the worst things in the major. Our findings suggest that the women in our cohort did not feel their gender had a significant impact on their experiences in the CS program at Carnegie Mellon. We see this as a positive sign of the Women-CS fit.

Again, there were many opportunities for students to comment on gender issues during the interviews, but, for the most part, comments only surfaced when gender was addressed specifically. During the interviews, we asked female students two questions specific to gender issues: "What has it been like being a woman in CS overall?" and "Have you experienced any problems in the program because you are a woman?" The overwhelming sense of being a woman in CS at Carnegie Mellon was positive:

> I came in at a time where it was changing; there was still that lingering idea that this was new that women were here, and it's a problem. I think now it's just sort of yeah, women are here. By now the class with very few women is already gone, all the classes now have plenty of women. So I think it's not as big of an issue anymore.
> – Female Senior, Class of 2004

This woman felt less like an anomaly:

> I sometimes forget. Not that I forget I'm a girl, but I don't feel this constant, "I am a female in computer science. I am a female in computer science." I'm like, "I'm a computer science student and, oh, hey, I'm a girl."
> – Female Sophomore, Class of 2014

The spectrum of responses ranged from enjoying being noticed, making them feel quite special, to simple affirmations that being a woman in CS was not an issue, to positive reactions with a reservation. In the simply affirmative group, students voiced such comments as: "I think it's really awesome," "It's been cool," and "I've have had an excellent time." Some commented on how great it was to have female friends, for others there were still too few women. Other women suggested their experiences were no different from the men's: "I don't really know if I can say it's been any different than a male's experience here in computer science." "Most of the time I don't think I really noticed," and "I think it's been pretty much the same that it would be for a guy." One woman said:

> Most people don't really seem to care about my gender. They care about whether or not I can solve problems.
> – Female Sophomore, Class of 2014

Several women noted advantages (e.g. more attention from recruiters, feeling admired by non-CS majors, and the occasional special events exclusively for women provided by *Women@SCS*). In the 2004 interviews some women offered positive comments tempered by a reservation reflecting some irritation at the implication that women were accepted into the program because of their gender.

> I think it's been pretty much the same that it would be for a guy. Umm, except some people say I got in because I was a girl, although, this was from a guy who got rejected from the School of Computer Science.
> – Female Senior, Class of 2004

For the most part such comments were hearsay, not first-hand and usually early in their years at Carnegie Mellon. Perhaps this indicates that for some women it just takes a little longer to feel the Women-CS fit. Since that time the "getting in because you are a woman" comments have practically disappeared.

We also asked the men to speculate what they thought it was like for women in the program. Their responses were interesting. Men frequently pointed to the difficulties women must face because of being outnumbered. One student said that some of the CS clusters look like "someone's idea if a frat house. I think that it's got to be tough." At the same time when asked if they had any advantages being men none of the men thought they did. Two men in the 2011-2012 interviews alluded to the gender imbalance and the possibility of women having fewer friends, but this was phrased as a negative for women rather than an advantage for the men. These men made interesting observations on the evolving acceptance of women in the program:

> I do think there's a much more general acceptance of women than my first year. I haven't heard people say as often, "I'm opposed to admitting more women," or lowering admissions standards. . . . [Some] individuals still feel that way but it's not a part of the culture anymore.
> – Male Senior, Class of 2004

> There are not a lot of girls in computer science, but as far as like sort of the negative aspects you would think of—discrimination or sort of looking down on someone because they're a girl in computer science or thinking they're not as confident—I haven't seen any of that at all.
> – Male Sophomore, Class of 2014

Our students' attitudes and opinions reflect a range of perspectives on being a woman in CS. Clearly, it is not possible to generalize about all women. And yet we believe that the culture of the school has changed dramatically for women. Prior to the 1990s the school had elements of the "locker room mentality" that Gurer (2002) found common at that time. Indeed, some male graduate students felt quite at ease having pornographic screen savers in full view.[50] This practice was part of the computing culture, although we suspect it was not just women who found it inappropriate. Nowadays, such a practice would be frowned upon, and we have not heard or seen anything so overtly sexist in recent years. Clearly, cultural change at Carnegie Mellon has been quite dramatic.

Summary

The 1995-1999 Carnegie Mellon studies found a perceived gender divide in students' attitudes to CS. These studies were conducted in an environment with very few women and with a student body that was admitted for its programming proclivity. We argue that the experiences and perspectives of the women in these studies were shaped, in part, by the computing culture of the time and their minority, and sometimes token, status.

In contrast, through the voices of our students in the 2002, 2004, 2009-2010 and 2011-2012 case studies, we heard a spectrum of attitudes and interests towards CS reflecting many gender similarities. We did not see a cultural norm in CS represented by the "male hacker" even though our students would agree that in the broad culture of the United States that stereotypical figure was still dominant. Instead our students see themselves and their peers as representing a diverse range of personalities and attitudes.

We did not find a gender divide in attitudes towards applications and programming, nor any evidence that men were less interested than women in doing useful things with their CS knowledge. If we look more broadly this should not be surprising. In the School of Computer Science we witness many of our faculty working on ideas that benefit the world beyond the CS community, and our faculty is by no means female dominated. For example, in a 2008 interview with *Carnegie Mellon Today*, Carnegie Mellon Turing award winner and CS professor, Ed Clarke, made it clear that "the practical application" of his work was very important to him: "I enjoyed writing the thesis and doing the research, but I was a little disappointed that the results had no practical application whatsoever." Later, at Carnegie Mellon, Clarke developed a now famous practical application, the Model Checker (Bails, 2008, p. 24).

A new culture of computing has emerged in the post-1999 more balanced environment; an environment shaped by improved gender balance, a broader range of student personalities, and enhanced opportunities for women students offered through *Women@SCS*. Clearly major changes have occurred, changes, which reveal the significance of culture and environment as major contributors to student perspectives on the field. At the same time these students have not been passive recipients but rather active players shaping the CS environment and contributing to change. Of all the changes we have found perhaps the most significant is *the emergence of the Women-CS fit*—a welcome situation in which women fit into the CS culture, contribute to it and are successful in the field alongside their male peers.

CHAPTER 6

Women@SCS: A Professional Organization Hosted by the School of Computer Science[51]

The most important part of Women@SCS for me has been meeting and interacting with upperclass women in the School of Computer Science regularly. I never would have met them, except for maybe in a teaching assistant setting, and I definitely would not have felt comfortable asking them questions about all aspects of campus life—job fairs, housing, time management, etc. I have never felt like an outsider in the School of Computer Science, and I think an important reason for that is that I have always had close relationships with other women in the school through Women@SCS.

– Carnegie Mellon Female Senior, Class of 2013

One of the school's major initiatives, recognized as one of the school milestones[52] (focused on women in CS but which has turned out to bring much broader benefits) has been the development of *Women@SCS*. This is a professional organization of undergraduate and graduate students and faculty hosted by the School of Computer Science with a budget from the school at the discretion of the Dean. The organization sponsors activities and events designed and implemented by interested members of the current community of students. *Women@SCS* also runs an extensive program of outreach activities aimed at providing opportunities, information and encouragement to the next generation of potential CS students. *Women@SCS* is an open organization and men are welcome to participate at the organizational level. Several of the year-round events and activities are open to the entire undergraduate student body.

Those of us working on women's and girls' issues in CS face a particular problem. How do we negotiate providing much needed opportunities and a community that facilitates access to those opportunities without making women think they are in need of "support"? Many women, as Kanter (1977) infers in her classic study, have no interest in joining women's organizations in part because they fear being associated with the "weakness" of women or those with less power. At the other end of the spectrum some women feel there is a stigma attached to being seen as "feminist" and "aggressive." For others who believe we've reached gender equity the very idea of being separated by gender is problematic. So,

how has a women's organization like *Women@SCS* been effective in this climate and how has it become integral to the culture of the department? Although it may sound clichéd, our philosophy has been to let our actions speak for themselves.

"Not a Support Group"

While some might describe *Women@SCS* as a "support group," this label suggests a limited and faulty understanding of its function. Indeed, its function, structure and activities are very deliberate—and labor intensive (Blum and Frieze, 2005). In our experience we have found that so called "support groups" involve students doing more for the community than those not involved—they are activists working on behalf of their participants or on behalf of all students for the benefit of everyone. *Women@SCS* has followed both directions.

Women@SCS started out as a women-only group in 1999 and has grown and evolved to be more *inclusive* and *integrated* into the School of Computer Science here at Carnegie Mellon. In many ways this is ideal. But not all students in CS are so fortunate. On top of this the general consensus of late is that for women to be successful in male dominated fields they need to develop strong male allies. *Women@SCS* has been fortunate in being able to do this. Of course no one wants women and minorities to feel like separate species; we'd all like to be treated equally and fairly, but as research into unconscious bias[53] shows us this is not the case. Some women and minorities may feel isolated; they don't have anywhere to turn except to each other. In this case students can gain tremendous benefit from connecting in a women-only and/or minority-only group. We believe there is great value when groups of under represented students are effective only for those who participate in them; in this case so called "support groups" are much more than an additional resource—they can provide the key that is essential to persistence, to self-efficacy, and to a positive student experience.

> Particularly for underrepresented students, a sense of belonging depends on their ability to identify with an environment that allows for the feeling of inclusion. This includes identifying with fellow students, finding belonging among student groups or organizations. (Smith, 2010, p. 2)

Between 1999 and 2002 the incoming CS classes at Carnegie Mellon, with their improved gender balance and broader interests and personal-

ities, were beginning to make their mark on the culture and environment of the department. More students were showing a range of campus-wide interests and forming campus-wide friendships. This stands in contrast to the 1990s when students' social lives were centered around programming camaraderie (Margolis and Fisher, 2002). By 2002, *Women@SCS* was increasing the visibility and impact of women in the department. For many women it meant "a greater sense of community than before" (female senior, class of 2002). Soon after, *Women@SCS* started working inclusively to improve the social and academic life of all. Over the next few years these trends would continue and strengthen, re-shaping a culture in which women (and men) could thrive and be successful. In this way *Women@SCS* has become a valuable asset to the Computer Science Department and to all students who wish to participate. We believe this direction is one way for a women's organization to have impact and be successful.

The Work of *Women@SCS*

Women@SCS is an organization that includes all female students in the School of Computer Science, in other words, there are no membership applications. Students are automatically included when they enter the School of Computer Science. The *Women@SCS* Committee represents the core group who are most active in building and implementing our programs. Under the leadership of our students *Women@SCS* provides crucial educational, professional, and social experiences to explicitly create an environment not typically available for those in a minority situation (Blum, 2004; Frieze and Blum, 2002; Frieze et al., 2006). Traditionally, many of the experiences that the male majority benefits from often spring from casual or informal exchanges in social settings. For example, in an undergraduate CS program, male students often have the opportunity to discuss homework with roommates, with friends late at night, or over meals. Course and job information and recommendations are passed down from upperclass students, from fraternity files, and from friends. Women students being in the minority, do not have access to, in fact are often excluded from, these implicit, informal, and important advantages. As one proceeds into the professional world, similar phenomena can occur (Blum and Frieze, 2005a; 2005b). So, *Women@SCS* engages in action and creative intervention to offer women access to similar opportunities. We also provide opportunities for women to develop programs that benefit their peers. (Detailed examples are provided in the section below: Student Leadership: The *Women@SCS* Committee).

As *Women@SCS* has evolved the organization has built a strong pipeline of connections at all levels, connecting faculty with students, graduates with undergraduates, and all with our local communities of K-12 students, teachers and families. *Women@SCS* provides many opportunities for women to network, to meet socially, to present at conferences, and more generally, to work on their professional development skills. At the same time the organization has strived to become a great resource for all. One example of women's impact and integration was the initiation of the student-to-student (no faculty allowed) advice session for all undergraduates in the department and now held each semester prior to course registration. The event attracts a roughly 50/50 male to female audience. Students from *Women@SCS* organize this event in which seniors and upperclass students discuss their views on classes and teachers, following up with a question and answer session. While this kind of activity goes on quite naturally among students on a day-to-day basis, by formalizing the event the organization helps to ensure that those in the minority do not miss out. Furthermore, the event provides visible leadership opportunities, which can affect how women are perceived. Another event, SCS Day[54] (started by *Women@SCS*), celebrating the diversity of talent in the School of Computer Science is now a major initiative embraced by faculty, staff, and students throughout the school.

Why We Need *Women@SCS*

On a day-to-day basis we witness the seemingly boundless energy and enthusiasm of the *Women@SCS* Committee[55] (the core active members) as they design and implement an extensive program of activities for the on-campus community and beyond. We never cease to be amazed at the commitment and creativity of these students, especially given the demanding and time consuming academic programs they are pursuing. But we also see how much they benefit from their involvement with the organization, growing more confident, gaining leadership and public speaking experience, meeting professionals in their field, designing and implementing specific events, while all along offering sound advice and strong mentorship to younger students.

> *Women@SCS* has exposed me to many opportunities that I wouldn't have otherwise been aware of, and has encouraged me to take full advantage of them.
> – Female Junior, Class of 2014

For the most part these "growth" and benefit factors are intangible, difficult to measure, nor have we had the funding and resources to evaluate our program in any objective way. Indeed, we have focused our resources on action, and on developing and providing those opportunities and experiences that just seem to make sense! Several studies, however, have provided evidence for the value of having a program like *Women@SCS*; especially with respect to providing mentors, role models, and network systems. Gloria Townsend's paper on mentoring and role modeling points out: "The literature of gender issues in computing steadfastly and uniformly has advocated the use of mentors and role models (M&RM) for recruiting and retaining women in computer science" (Townsend, 2002, p. 57). Townsend notes the contributions to this literature by some of the notable women and organizations in the field: Tracy Camp, Vicki Almstrum, Denise Gurer, the Association for Women in Science, the Mentornet organization, among many, many others.

Isolation is a primary factor negatively impacting the experience and performance of women and minorities in computing (Etzkoitz et al., 2000; Taylor, 2002; Smith, 2010). Some studies note the importance of same-sex peers. Sanders' study of girls' attitudes about computer use notes, "I found that it wasn't the predominantly male cast of the computer room that kept girls away, as I had thought, but rather the absence of their girlfriends" (Sanders, 1995, p. 154). A 2004 British think-tank publication, "Girlfriends in High Places: How Women's Networks are Changing the Workplace," suggests that networking is an essential professional tool, arguing that "(d)eveloping women's networks can be an effective strategy for overcoming some obstacles to diversity because they challenge the invisible structures that hold women back at work" (McCarthy, 2004, p. 10). This perspective is very much in line with the mission of *Women@SCS* which has evolved *not* as a "handholding" support group, but rather as an action oriented organization in which women take leadership roles to formalize programs and opportunities that often go on informally among the majority males.

> If I hadn't started to get involved in *Women@SCS* my sophomore year of college, I would have almost certainly dropped out of computer science. I had been to a few (very few) events first year, but becoming more active made me believe that I could do something to make the School of Computer Science a happier place. I've now become one of the most involved students at the School of Computer Science.
> – Female Senior, Class of 2013

A 2006 nationwide study of undergraduate departments by Cohoon and Aspray, concluded that numbers of women peers and the potential for available same-sex peer support had a strong impact on women's attrition rates (Cohoon and Aspray, 2006, p. 216). One of the first programs developed by *Women@SCS* was the Big/Little Sisters mentoring program, which ensures that students have same-sex peer networking. The program matches first year women with upperclass students as soon as they enter the CS major and has since grown to provide graduate sisters for undergraduate women thinking about graduate school. *Women@SCS* also holds a regular graduate lunch series, where graduate women get to meet each other across the seven departments within the school.

Women faculty in the School of Computer Science has been, and continues to be, a critical group for encouraging, mentoring and simply being there as amazing examples for both our graduates and undergraduates. At the same time female faculty in CS, being in a minority, are often called on for university "service" work (panels, committees, etc.) at much higher rates than their male colleagues. This makes it all the more commendable that our female faculty have played such a strong role in *Women@SCS* events and activities, always ready to join socials, or lead teams, or discuss their research with our students. This is not to belittle the efforts of our male faculty, indeed it warrants repeating that without the valuable support of our faculty (men and women) *Women@SCS* could not have flourished in the way it has.

The proportion of women faculty in the School of Computer Science currently runs at 21%, a little above the national average. This means that many undergraduate students go through the CS major without having been taught by women faculty. Nevertheless, the faculty/graduate/undergraduate community building of *Women@SCS* has, to a large extent, helped compensate for having fewer women faculty, a view that this female student made clear: "The *Women@SCS* events and that kind of thing is an advantage because you get to expand your network, meet more people, meet more faculty and graduate students." *Women@SCS* implements a program of faculty-student mixers for undergraduate and graduate students including faculty panels and invited speakers. In sum, our students get to see and meet lots of women with a wide range of backgrounds and interests.

> *Women@SCS* creates an excellent chance to meet and discuss with the most intelligent people in this field, to learn about the most advanced research, and to develop a better career for ourselves.
> – Female Ph.D. Student

The following section includes a brief history of the inception of the organization, and describes some of the factors we have found essential to building a student organization, and to designing activities and events that can encourage and sustain a community of women in CS. We present a sampling of concrete activities and events in the hope that these might suggest possibilities for a like-minded student organization at another institution. We have found it essential to have a core group of activist students (the *Women@SCS* Committee) at the helm; students who provide encouragement, creativity, and effective student leadership. Since its inception the Committee has been action oriented. We believe the best way of overcoming any problems is by just *doing* and this philosophy has been welcomed by faculty and students alike (Blum and Givant, 1980). And, as Lenore Blum observes, an important but nevertheless little acknowledged component of professional training and success derives from the professional interactions that take place in social settings. Thus, the events designed by the *Women@SCS* Committee generally combine professional *and* social activities that help foster community, skills and growth.

Student Leadership: The *Women@SCS* Committee[56]

With the dramatic increase in the number of women entering the CS program in the fall of 1999, the school was faced with a great opportunity, and a great challenge. It seemed clear we would be in danger of losing many of the new recruits if we were to conduct business as usual within the atmosphere of a traditional CS department.[57] Hence, it seemed critical to work closely with students who might guide us to appropriate action. By 1999, graduate women students from the School of Computer Science had already recognized the value of bringing together the women who were spread thinly across all the School of Computer Science departments. Representatives from among the newly increased numbers of women undergraduates came on board and the *Women@SCS Committee* (known here simply as 'the Committee') was born. *Women@SCS* has since become catalytic in building an environment in which the new student body can flourish.

> *Women@SCS* has empowered me to seek leadership and put myself out there when I otherwise would not have. I would feel lost and confused if I didn't have the strong support base to help me grow as a computer scientist.
> – Female Junior, Class of 2014

By the fall 2000, the Committee had a total of 23 students and had separated into a graduate sub-Committee of 12 students and an undergraduate sub-Committee of 11 students. The separation was necessary because of divergent interests between the younger students (who preferred a combination of social and mentoring activities) and the more professional/research oriented graduate students (who preferred focused discussions and professional networking activities). Connections between the sub-Committees continue to be maintained by holding joint meetings and events.

All four years of the undergraduate level are now represented, as are most of the graduate departments. We have found that a core group of Committee members are extremely active and participate on a regular basis while other students attend meetings and help out with events whenever they can. This situation has proved to work well. Students are under no pressure to do Committee work but will happily help out when called upon. At the same time, the more regularly active members can hold leadership positions within the Committee, direct meetings, instigate discussions, and plan events.

> To me, *Women@SCS* is a community where everyone is some combination of my friend, mentor, or mentee. There are so many leadership opportunities for anyone who is looking not only looking to promote women in the CS community, but also hoping to provide useful services to our CS community in general. I love *Women@SCS* for its members, objective, and of course, the fun we all have in the process!
> – Female Senior, Class of 2013

The Committee has turned out to be *the* driving force behind our proactive efforts to improve the academic and social climate for all women in the School of Computer Science. As the Committee has grown and thrived, so have the numbers of women students who attend the Committee's programs of events and activities. As the Committee has become a respected part of the School of Computer Science the atmosphere for all students has greatly improved. Thus we strongly believe that building an energetic, action-oriented Committee is key to building a successful community of women in CS, which ultimately can enhance the entire CS community.

Some Essentials for Building an Effective Organization

Women@SCS has been successful—but this success has come from several essential components: faculty and institutional support, the program director, the Committee leaders, regular meetings and communication mechanisms and the inclusive nature of the organization. Below are some of the essentials for building an effective organization.

- *Faculty and institutional support:* The Committee needs a dedicated senior faculty member who will promote the interests of the group throughout the department, school, and the university. Professor Lenore Blum has continued in this role since 1999.

- *The Women@SCS Program Director:* Carol Frieze is the Director of Women@SCS and has worked with the organization since 2000. She has formed strong ties and support networks on behalf of students. At the same time she has formed a close and mutually respectful relationship with Committee members. This gives them a strong sense of self-worth and provides a bridge for communicating with other faculty and administrators. The Director, supported by an administrative staff member, helps with the day-to-day organization of activities, events, and meetings and works closely with the Committee. Members of the Committee are keen to invest their time, energy, and ideas for the good of the community. However, it is vital that the Committee has organizational support so that its members maintain good academic standing and do not "burn out." Carol ensures the Committee has the organizational support needed. She oversees the Women@SCS website, networks throughout the university with staff, faculty, and administrators (and beyond) in arranging the Committee's events and activities, works with students on outreach activities, and has become a sounding board for members' ideas and questions.

- *Meetings:* Women@SCS holds regular Committee meetings (in an official meeting room) with an agenda and a set time. Students organize future events, review past activities, comment on classes and curriculum issues, brainstorm and share ideas, and review the website. Meetings also provide a safe, non-judgmental environment where students can ask for help, and give it in return. When new students arrive they are encouraged to attend meetings to find out more about the Committee and its goals. Occasionally a guest, usually faculty or an administrator or campus visitor, is invited. This allows the Committee to

meet faculty and administrators on an entirely new level for an exchange of ideas and information. Research suggests that this kind of personal involvement with faculty and administration has been found to be particularly important to women students (Cuny and Asprey, 2000; Fox, 2000).

- *Committee leaders:* We have found that Committee members are happy to have leadership from the senior members, and that it works best to have two leaders (within each sub-Committee) who will be responsible for leading the meetings, acting as general spokeswomen, and coordinating with the Program Director. Recent leadership positions have included organizing academic events (e.g. pre-registration, choosing a minor), social events (e.g. movie nights, dinners), outreach activities (e.g. Roadshows and TechNights), professional skills training (e.g. public speaking, interviewing), and the Sisters mentoring program.

- *The Women@SCS student-run website:* The website represents the public face of the organization and increases its visibility. The website has become a focal point for announcing activities, for highlighting and celebrating the many special accomplishments of women throughout the school, and for providing resource information. The web team also conducts faculty interviews for the website. The *Women@SCS* website is reviewed at Committee meetings and all members are encouraged to submit event announcements and items of interest. See: http://women.cs.cmu.edu/

- *Maintaining current distribution lists (d-lists) of women (faculty, graduates, undergraduates) in all departments:* Women@SCS is an organization that includes all undergraduate and graduate female students—de facto—there are no membership applications. Students are automatically included when they enter the School of Computer Science. Another d-list for the Committee represents the core group who are most active in building and implementing our programs. Carol maintains the d-lists, which have become essential tools for our voluminous amounts of email communication. D-lists not only provide an efficient tool for disseminating ideas, getting feedback, announcing meetings, events and scholarship opportunities, but also for tracking the numbers of women throughout the department(s).

- *An open organization:* Women@SCS has benefited from being an inclusive organization. Several undergraduate men have been

actively involved with the organization. For example one man, who became involved as a first year student, became an excellent *Women@SCS* web team leader throughout his junior and senior years. Other men have taken a more casual approach and have attended the occasional meeting, some simply out of curiosity. Nevertheless they have been welcomed, and the Committee, in turn, has welcomed their help with events and activities. Graduate men are not so involved with community building but play a strong role in our outreach activities.

- *Women@SCS strives to be an asset to the department, school and the university as a whole:* Carnegie Mellon's School of Computer Science has called upon the *Women@SCS* undergraduate Committee to provide direct input on issues such as the curriculum, advising, and climate. Committee members have been invited to participate on panel discussions to examine future practices for Alumni development. *Women@SCS* has been featured in local newspapers and on public television and in the Carnegie Mellon Today magazine, and in the School of Computer Science *Link* magazine. The *Women@SCS* Roadshow was part of the celebration of the Computer Science Department's 50th anniversary. In the inauguration of the new Gates Hillman Center a video representing the landmarks of Computer Science at Carnegie Mellon included the setting up of *Women@SCS*. It is clear that *Women@SCS* and by extension the community of women in the School of Computer Science, have now become a very valuable, articulate, and visible asset.

Events and Activities

The overall goals of *Women@SCS* as realized through the efforts of the Committee, are to promote the breadth of the field and its diverse community. The Committee generates a wealth of ideas, and expends an extraordinary level of energy.[58] The fact that a fresh crop of students joins forces each year helps sustain the energy output. But even more, we have observed the paradoxical, and yet clichéd, outcome: namely that "energy produces energy" and that "to give is to receive." Indeed, Committee members are the greatest beneficiaries of their involvement in running the show in terms of their increased professional experiences, contacts and growth, their self-esteem, and their academic and leadership successes and awards. Below are some of the activities and events sponsored by the organization.

- *First year orientation session:* A social gathering, scheduled during Carnegie Mellon's first year orientation week. Committee members invite new students in CS (women and men) to meet upperclass students to hear about their work and life in the Computer Science Department.

- *Big Sisters/Little Sisters:* This program pairs a more "senior" Big Sister with a Little Sister and provides an informal, but organized, set-up for support, mentoring and friendship, centered around a number of social events. Sisters are encouraged to email and meet outside of the organized activities. We have found that some students prefer this one-on-one set up while others prefer group-mentoring activities—we feel both formats are important.

- *Graduate BigSisters:* In 2005 we set up the Graduate BigSisters' program, the initiative of one of the graduate women who saw a gap in our Big Sisters/Little Sisters' mentoring program. The initiative pairs graduates with juniors and seniors in CS who are thinking about going to graduate school, with the aim of offering general information and encouragement along with specific advice on the application process. Ideally, the students meet together two or three times a semester and communicate and meet as Sisters as often as they choose. Graduates have also organized graduate-to-graduate informal mentoring/networking activities[59] called T-Hours, aimed primarily at providing opportunities for masters students to get advice about Ph.D. programs.

- *Pre-registration event* and *passing the torch:* The Pre-registration event serves as a mid-semester opportunity for providing general advice on the class registration process. The Passing the Torch event is held at the end of the academic year as seniors prepare to graduate and others prepare to advance their year. *Words of wisdom* given at these events include tips on succeeding, on what works, what doesn't, and recommendations on classes and professors. Faculty members are not allowed to attend the advice sessions so that students can speak freely to each other. These events serve to remind students that others have been through similar experiences, have survived/thrived, and are now positioned to embark on exciting and rewarding endeavors. These events are open to all CS undergraduates and have proven to be very popular.

- *Undergraduate research information sessions:* These events provide an opportunity for students to learn how and where to start the research process, and about the rewards of an undergraduate research experience. Graduates have led sessions for undergraduates and at other times the university's undergraduate research director has led sessions to explain the grant application process. Women students who have been involved in research projects share their experiences. Industry researchers who are also Carnegie Mellon alumnae have also led sessions.

- *Advice on graduate school* and *reading graduate school applications:* At the first event, graduate students talk candidly to undergraduates about their decisions to go to graduate school, the application process, and their future plans. At the second event, graduate Committee members read applications and give feedback to undergraduates who would like help with their applications to graduate school.

- *Grant proposals:* Our graduate Committee members have contributed ideas, feedback, and helped to write grant proposals for women in CS/IT related projects.

- *Study breaks:* Study breaks are led by women seniors and/or the Sisters' program organizers during exam time. They allow students a chance to hear advice, share test anxieties, and give reassurance as needed.

- *Invited speaker series:* Speakers from academia, business, and industry are invited (individually or on panels) to present technical talks, share their stories and experiences, offer professional advice, promote their workplaces, offer mentoring opportunities, and discuss gender and work issues. Guest speakers often join *Women@SCS* members for an informal dinner-social.

Social Activities

Social activities have been found to play a critical role in a successful college experience. "College persistence relies heavily on students' perception that they are academically and **socially** [emphasis added] integrated into campus life" (Smith, 2010, p. 2). In order for under represented undergraduates to build strong peer-to-peer networks and friendships some formal structure may need to be in place, at least initially. Below are some of the current and past social activities sponsored by *Women@SCS*.

- *Graduate/undergraduate socials:* Graduate and undergraduate students meet informally over lunch or dinner or the end of year picnic. We have found that many more undergraduates than graduates tend to participate, but the events are generally well attended.

- *Museum/Phipps lunch series:* For several years graduates and faculty met monthly at a local café and socialized over lunch. The lunches provided opportunities for women to meet others from throughout the seven departments of the School of Computer Science. The lunches are hosted by at least one active graduate member of *Women@SCS* and also provided an opportunity for her to answer questions about *Women@SCS* and explain the goals and program of activities.

- *Faculty/student dinners/breakfasts:* These dinners and breakfasts provide a chance for students to meet faculty in a relaxed, non-judgmental atmosphere, and to increase the visibility of successful women computer scientists. We have found that a core group of senior faculty and a group of younger faculty show up regularly and are very supportive.

- *Annual graduate women's welcome potluck:* The Annual Potluck 'officially' kicks off the new academic year. The potluck has become a *Women@SCS* tradition having been one of the first events organized by graduates. It provides an opportunity for graduate students and faculty to get together, share home cooked food, and welcome the new graduate students and faculty.

- *T-Shirt design:* Occasionally student ideas seem incompatible. Very few agreements emerged as the Committee set about designing a *Women@SCS* T-shirt and new logo for the website. The T-shirt disagreement was resolved by inviting input from female faculty. Professor Jeannette Wing (former head of the Computer Science Department and now at Microsoft) suggested the running figure logo below, which everyone seemed to like and was adopted!

T-shirts were given out to the School of Computer Science students in exchange for donated, decent items of clothing for the local women's shelter. The T-shirts proved to be very popular and the project was very successful. The more permanent, public website image is open to further debate. We are, after all, an evolving community.

- *Class mixers:* Students noticed that after their first year there were very few opportunities to get together with their own class. Class mixers are set up as social events, once a semester, as an opportunity for each class—first years, sophomores, juniors and seniors—to get together with just their classmates.

Conferences

Below are some of conferences supported and attended by the organization.

- *The Grace Hopper Celebration of Women in Computing:* Committee members, along with the School of Computer Science faculty and researchers, have presented at several Grace Hopper Conferences (2000, 2002, 2004, 2006, 2010, 2012, 2014). Our presentations have included panel discussions on: the Carnegie Mellon experience in increasing the participation of women in CS; how the ubiquity of computing is closely linked to the ubiquity of women in computing; increasing the pool of women students in graduate CS/IT programs and positioning them to become future university CS/IT faculty and leaders in the field; sustaining outreach programs; and the OurCS workshop, a research focused workshop for undergraduate women in CS.

- *Girls, Technology, and Education Forum:* The Committee presented an afternoon forum focusing on girls and technology in education and entertainment. The event successfully brought together more than 160 teachers, academics, students, and members of the business community for a full afternoon of talks and brainstorming. Together, the group discussed topics ranging from classroom strategies, to software game development and beyond. As an added benefit, Committee members were provided an opportunity to practice their public presentation skills, their teamwork, their organizing abilities, and most importantly, to share their expertise and perspectives. This event was funded and jointly arranged with the School of Computer Science External Relations Office.

- *The Richard Tapia Celebration of Diversity in Computing*: A group of five undergraduate Committee members attended the first in a series of events designed to celebrate the technical contributions and career interests of diverse people in computing fields. Since then members of *Women@SCS* have attended and presented at the Tapia conference and students have participated in poster sessions.

- *Women in Engineering Programs & Advocates Network (WEPAN)*: Students and faculty have presented on outreach activities like the Roadshow and TechNights and on work done through partnerships with AccessComputing.

- *ACM's Special Interest Group for Computer Science Education (SIGCSE)*: Faculty and students have presented papers, panels and Roadshows at the annual SIGCSE conference.

Funding

Below are some of the sources of funding for the organization.

- *University and departmental funding:* Funding is essential for the Committee to put its plans into action. We have been fortunate in having administrative and financial support primarily from the School of Computer Science with additional funding from the Computer Science Department and from the university. Funding at this level gives value and credibility to the goals of the Committee, credibility to women's issues, and the need to improve the environment for women in CS. Funding *Women@SCS* has proved to be a very positive investment for the Computer Science Department and the university as a whole.

- *Industry funding:* The many computing-related companies, who are keen to recruit on campus, have also been a great source of funding for us, especially in helping to send students to CS-related conferences. Industry sponsors and private donors have also helped us initiate and sustain our TechNights program, the OurCS conference, to hold dinner/socials, to purchase Outreach equipment, and generally to help us *never say no* to the worthwhile activities the students want to hold.

- *Upstart/start-up grants[60]*: Funds for the Upstart/Startup Program were provided by Lenore Blum's Presidential Award for Excellence in Science,

Mathematics and Engineering Mentoring. The Program provided $250-$500 grants for imaginative School of Computer Science student initiated projects (e.g., for research, outreach, student activities or events).

Additional Activities

A wide range of additional activities (sometimes part-sponsored by *Women@SCS*) have included belly-dancing, an ice cream event at the annual CS undergraduate picnic, rock climbing at a local climbing wall, ice skating, a women's self-defense event in which students learned some basic self-defense moves, Holiday Shoebox Gifts collection for local women's shelter, and a guided tour of the *Carnegie International* (a contemporary art show). These activities organized by Carol and our students represent occasional activities rather than ongoing activities. Students are encouraged to try new events and if they spot a gap in our programs they usually are the first to make a recommendation. For example, leaders of the Big/Little Sister mentoring program noticed that although we have done a great job of connecting students across all years, women have few opportunities to meet up with their own class. Hence, a new "class mixers" program (mentioned above) was set up in which *Women@SCS* representatives from each year organize class socials.

There have been several major school-wide initiatives to emerge from core active members of *Women@SCS* including the Pittsburgh chapter of Computing Professionals for Social Responsibility (CPSR),[61] Tech-BridgeWorld[62] and SCS Day.[63] SCS Day, started in 2003, by a group of graduate and undergraduate students is a celebration of the diversity in the School of Computer Science at Carnegie Mellon. This is a dynamic event includes workshops, art exhibits, games, and a talent show with the Dean of the school acting as the Master of Ceremonies. The event has been embraced by faculty, staff, and students (and their families) throughout the school. All the members of the School of Computer Science community, undergraduate and graduate students, faculty, staff and alumni, are invited to display their talents and share their skills in a fun and relaxed atmosphere. TechBridgeWorld, hosted by the School of Computer Science, was initiated and is led by a Robotics Institute faculty member who was one of the founding members of *Women@SCS*. The TechBridgeWorld endeavor is successfully "spearheading the innovation and implementation of technological solutions relevant and accessible to developing communities; using technology to build bridges rather than exacerbate divides."

Women@SCS Outreach Programs

> For computer science to thrive, its story needs to be told to the outside world (especially high school students and their parents and teachers, as well as policymakers and the popular media) in a way that keeps the science and the ideas center stage. (Arora and Chazelle, 2005, p. 31)

Last but not least in this description of *Women@SCS* events and activities we present some snapshots of our extensive outreach programs. *Women@SCS* is especially keen to ensure that female and minority computer scientists are actively involved in presenting themselves, their work, and new images of the field to young audiences, their teachers, parents, and others. The Roadshow, TechNights (Creative Technology Nights for Girls), Adventures in Computing at SciTech (Pittsburgh Science and Technology Academy) and OurCS (Opportunities for Undergraduate Research) are the primary outreach vehicles. Our students' commitment to designing and implementing outreach activities is especially commendable given that their own studies are intense and time demanding. *Women@SCS* outreach programs started in 2003 and have been growing ever since. For example, students logged between 750 and 895 volunteer hours each year for 2010-2011, 2011-2012, 2012-2013, and 2014-2015. Our volunteers represent the priceless resource for our program, other costs (e.g. equipment) are covered by small but valuable industry grants and the School of Computer Science—this institutional support is critical.

- *The Outreach Roadshow*[64]: In 2003, members of the Undergraduate Committee designed and implemented their first outreach program, the *Women@SCS* Outreach Roadshow, one of our primary outreach initiatives for teachers and students. Since that time faculty and students have presented the Roadshow on campus, at conferences, and in local schools, and have reached thousands of K-12 students, parents, and teachers. By 2004, members of the graduate Committee had taken the Roadshow to the next level and had designed and implemented a Roadshow aimed at undergraduates on campuses across the nation. This was funded by a Sloan Foundation grant (now closed) and aimed to show undergraduates the enormous range of research related to computing fields.

The Roadshow is a highly interactive presentation given by small teams of men and women who discuss their own pathways to computing,

show the breadth of computing applications, and challenge stereotypes through a photo guessing game asking "Who Is A Computer Scientist?" Students promote the different career choices within computing fields and talk about their job experiences in various high tech companies, including the perks of jobs in computing. One important aspect of the Roadshows is to show the importance of problem solving skills and to include interactive exercises and games. We have found CS Unplugged[65] and CS4FN[66] provide great resources for our Roadshow activities. We try to ensure time at the end of the Roadshow for Q&A.

The Roadshow is always in demand. Feedback from audiences and from our own student presenters has enabled us to adapt Roadshows to different venues and audiences.

- *TechNights*[67] *(Creative Technology Nights for Girls):* Since 2005 *Women@SCS* has been running this free weekly program of informal sessions aimed at giving real hands-on technology experiences and skills to middle-school girls. The program was initiated and implemented by one of our graduate students. Graduates and undergraduates teach a different session each week (during the academic semesters), and girls from local public and private schools are invited to participate. Between 25 -35 girls show up each week, most returning regularly even though attendance is on a drop-in basis.

 Topics for TechNights vary greatly and have included robot design and robot programming, 2-D animation, protein folding, web design, solidworks, decision trees, dynamic programming, Internet safety, stop motion movie making, and much, much more.[68] Observations of girls who attend TechNights help confirm our belief that given the opportunity to explore technology and computing related activities in an open and encouraging environment girls are eager and adventurous to learn and show a wide range of interests and attitudes.

- *OurCS*[69]: *Opportunities for Undergraduate Research in Computer Science*: *Women@SCS* designed and implemented a first-of-its-kind research focused conference (OurCS) for undergraduate women in CS. The conference, offered in 2007, 2011, 2013 and 2015 sponsored primarily by Microsoft Research, Oracle, Capital One, and the School of Computer Science, has attracted participants from across the nation and beyond. OurCS features some of the world's current and future leading female computer scientists as speakers. More significantly,

OurCS was designed to involve students in real-time research—during the conference students work on research problems in teams (ideally 5-6 students) guided by scientists from academia and industry. Participants have worked on a variety of research topics ranging from "Disagreement in Wikipedia" to "Claytronics," to "A Multi-Robot Choreography." At the end of each conference the teams present their findings to all OurCS participants.

OurCS is unique in bringing together research professionals and CS undergraduates in one venue for an intense three days of problem solving. As well as engaging students in research, the conference is a great venue for networking, mentoring, and gathering advice on going to graduate school. Conferences like OurCS are helping to rev up and inspire young women to be future leaders in a field.

- *Adventures in Computing (formerly known as Computational Thinking)*: This outreach program, designed and led by graduate students, aims to provide middle school students (6th to 8th grade boys and girls) with opportunities to discover and practice basic principles of computing and computational thinking through fun activities. Since the fall of 2010, the program has been offered at the Pittsburgh Science & Technology Academy (SciTech). SciTech is an urban public 6-12 school in the Oakland neighborhood close to Carnegie Mellon. The program is held during the activities sessions at SciTech where middle school students choose from a wide range of programs. Students who choose Adventures in Computing can explore a range of creative technologies and tackle puzzles and problems—sometimes involving computers and sometimes unplugged, and most recently using arduinos/maker culture. At the invitation of one great SciTech teacher the team has also started working on a regular basis in the science classroom—a testimony to their effectiveness. In this way all students in the class will get exposure to Adventures in Computing.

- *PBS filming of Women@SCS:* Bonnie Erbe, producer of *To The Contrary*, a PBS news program on women's issues, came to campus with her crew to film and interview the School of Computer Science faculty and core Committee members. The show provoked a lively debate among our Committee members and faculty, demonstrating that while we may share many common goals, we also hold a wide range of perspectives on gender and computing issues.

- *The Women@SCS outreach video:* Undergraduates developed a short video *What is Computer Science?* aimed at demystifying CS. Faculty and undergraduates participated, giving their thoughts on the field. The video is featured on the *Women@SCS* website and can be seen at: http://women.cs. cmu.edu/movie/WhatisComputerScience.wmv

- *Expanding Your Horizons (EYH):* Members of *Women@SCS* have participated in EYH in 2000, 2001, 2002, 2003, 2007 and 2012. *EYH* is a nationally held one-day event aimed at increasing young women's interest in science and mathematics. Our students have run workshops called "Is There A Robot In Your Future?" and the "Magic of Computer Science" for middle school girls at the local *Expanding Your Horizons* conference.

- *GameMaker workshop for deaf and hard of hearing high school students:* This one day workshop was organized by *Women@SCS* and sponsored by AccessComputing whose mission is to increase the participation of people with disabilities in computing fields. The workshop was motivated by our partnership with the Western Pennsylvania School for the Deaf (WPSD)[70] and run by two graduate students who instructed 13 local high school students who were deaf or hard of hearing in a day of game development. Professor Karen Alkoby from Gallaudet University gave an inspiring keynote speech. Two Gallaudet seniors worked as assistant instructors throughout the day as well being great role models.

We have not been able to describe all of the *Women@SCS* outreach activities but we hope we have provided a good snapshot of some of our most important efforts. More recently, working with the University of Pittsburgh and Penn State University, we co-sponsored the NCWIT Aspirations in Computing Affiliate Award. This brought over 50 high school girls from Central/Western Pennsylvania and West Virginia together to recognize their achievements in computing. In 2015 we celebrated our third local Aspirations awards.

Anecdotal feedback from K-12 teachers and parents tells us how much they need, and appreciate, the examples and materials we use to demonstrate the breadth of CS. There seems to be a desperate need for teaching resources that situate programming in the wider context of the field. Teachers also seem to share our desire to try to break down the stereotypes that surround the field but they rarely have the resources to do so.

Benefits to Our Student Volunteers

We believe that successful outreach must benefit both volunteers and the groups served. If you were to ask our student volunteers why they do what they do, they would not identify self-enrichment as a motivator; in fact the opportunity to give back, to make a difference, to serve the community are the most frequent reasons given. But from the perspective of faculty and administrators involved in organizing outreach (and always watching to ensure students do not burn out) we have observed the many unexpected benefits they receive.

The *Women@SCS* outreach programs provide our students with leadership, teaching, and public speaking opportunities. By having graduates and undergraduates team up to develop and implement the presentations, numerous opportunities for mentoring and learning arise. We believe these outreach programs help our students build confidence, and provide them with opportunities to practice their skills and illustrate their knowledge in a fun environment. In addition, Little et al. (2001) explain that as the field of CS becomes more globalized the abilities of our students need to go beyond the expected technical expertise to include the ability to be comfortable with a wide range of people from different cultures and backgrounds. We believe our outreach programs highlight a key concept coined by Lynn and Salzman (2007) in that we help our students go way *beyond the technical*.

Students' Perceptions of *Women@SCS*

In the following sections we offer students' perceptions of the *Women@SCS* organization through the voices of the 2004 representative cohort. Students were given an opportunity to explain their perceptions of the *Women@SCS* organization. They were asked whether they had heard about the organization, if they had attended events or had been involved with the organization, and whether it had had an impact on their experiences, or not, as they proceeded through their years at Carnegie Mellon. We begin with the women *non-Committee* students, followed by the *male students*, and finally the *Women@SCS Committee members*.

Female Students' (Non-Active Members) Perceptions of *Women@SCS*

All women said they had heard about *Women@SCS*. One woman pointed out "one of the advantages of it that I see is just the visibility." Indeed we believe that *visibility* is valuable to women in a minority situation; those

not actively involved in *Women@SCS* can benefit from the community and appreciate its valued presence in the department, "even in ways I don't really realize," remarked one woman. Most students had very good impressions of the organization. Of the fifteen women in the cohort who were non-active members, eight of them had very positive things to say, two had mixed responses, four were unclear or non-committal, and only one woman held a negative view.

Several women mentioned how much they enjoyed the events, and many noted appreciation for the Sisters' program, the pre-registration advice sessions, and especially for the networking events such as the faculty/student dinners, events with graduate students, and invited speakers. For some students, the most important aspect was simply the act of connecting "the different classes like first year student, sophomores, and juniors." For one woman, the *Women@SCS* events helped build her confidence and gave her the opportunity to hear from other women "one step ahead" of her: "It definitely helped me in the first couple of years. Yes, trying to find my place and getting more confidence. I think that's where I definitely got it from was from *Women@SCS*." Another woman commented that seeing women professors and graduate students helped to counter her impressions that only men were successful in the field:

> I especially like the events [with] women computer science professors and students. When I see there are women Ph.D.s and they are teaching at Carnegie Mellon University, they must be really smart too, I really liked seeing [and] getting to interact with them.
> – Female Senior, Class of 2004

One woman felt she did not need *Women@SCS* personally: "I was doing fine on my own as a woman in computer science" nevertheless she "appreciated that they were there and what they were doing for other women."

This particular cohort of women students (what we called our class in transition) was admitted in 2000 under the new admissions criteria that *de-emphasized* prior programming. During their first couple of years some had heard, or experienced, backlash comments suggesting they were admitted because of their gender. *Women@SCS* Committee members often addressed this issue at meetings and events. For one woman who had been questioning why she had been admitted (when she had

no programming background) hearing other women explain the reasons at a *Women@SCS* event had made a difference: "after I figured out what the real reason was, which they explained at one of the meetings, [it] made a lot of sense."

The one woman who voiced negative comments said she felt she "would rather be a person at the School of Computer Science than recognized as being a woman at the School of Computer Science." This is reflective of the challenge mentioned before for those of us working on women's and girl's issues in CS. On one hand, it shows a healthy resistance to gender separation paradigms, but it can also prevent women from taking advantage of opportunities that may be of benefit to them. Several women in our cohort had heard, or felt, that the group of active members was somewhat "cliquey." This was an understandable perception. The group of women who led the *Women@SCS* Committee had developed strong bonds over the years and were very close friends. In many ways, this became a *strength* for the organization, but it also generated a negative perception that needed to be addressed. In fact, the group was aware of this "exclusionary" image and made extra recruiting efforts. One of the major issues for the organization (and we think one that applies to many organizations for women and minorities) is communicating what you do/who you are, and *what you don't do*. *Women@SCS* has made determined efforts to announce its positive mission of offering many opportunities and new experiences, and has tried to dispel any mis-representation. Communication efforts always need to be continued and be improved.

Male Students' Perceptions of Women@SCS

All men said they had heard about *Women@SCS*. The men voiced an interesting range of impressions including some very positive impressions, such as, "I think it's a pretty good organization, I mean it's trying to bring more opportunities to women in computer science which is a good thing because I think it's kind of imbalanced in this field." Several noted the "action-oriented" aspects of the organization, and that some events were open to all students—several men had attended at least one event organized by *Women@SCS*. Some had mixed impressions, or were unclear about the details of the organization. One man described the organization as "the women mafia of CS" but also noted they had "done a lot of positive things." Another man had a rather vague, but fairly positive, impression: "It's sort one of those organizations I know exists, and it's out there, and they do good stuff, but I'm

not really sure about the details." One man claimed the organization was not political enough, and needed to make its mission clear, and if he was running the program he said "I might do it differently." It seems evident that *Women@SCS* needs to work harder at getting its message and mission out to *all* students.

It is worth mentioning that although it did not apply to the 2004 cohort, *Women@SCS* has had men participating actively on the Committee. Two men from the class of 2006, for example, were very actively involved on the *Women@SCS* Committee throughout their years at Carnegie Mellon. One male student had been involved because he was a minority student and wanted to contribute to *Women@SCS* and to the Society of Hispanic Professional Engineers (SHPE). The other student was an active student, campus wide, and joined the *Women@SCS* Committee because he felt it was the only student organization with any action-oriented presence in the Computer Science Department. This student eventually became the *Women@SCS* web team leader for almost two years and proved to be an outstanding member of the organization. Since then the organization has usually had at least one man continually contributing and very actively involved, helping to organize, plan and implement events, doing Roadshows and generally working towards the goals of *Women@SCS*.

Women@SCS Active Members' Views

Not surprisingly, the *Women@SCS* active members were the ones who benefited most noticeably from their involvement with the organization; for some the organization had proved to be pivotal as this woman indicates, "For me it's helped me get through a difficult four years of college." In the 2004 representative cohort five of the twelve active members of the *Women@SCS* Committee were included. All five Committee members talked enthusiastically about the opportunities they had, and the friendships they had made through their involvement with *Women@SCS*. Four of the five students got involved during their first year, and the fifth during her sophomore year; three Committee members were encouraged to be involved by other students and friends, while two others attended meetings, felt a good fit and decided to stay. All five students gave a sense of both *giving and gaining* from their involvement as Committee members.

This reciprocal "giving and gaining"[71] revolved around specific aspects of the organization but all combined professional *and* social activities:

- *Mentors and role models:* All five Committee members had been involved with the BigSister/LittleSister Program.[72] One student headed up the program for a couple of years, "It was nice to be able to be in charge of something. It kind of made you motivated to stay involved and do more stuff because you were in charge of a project." Another student suggested, "There are advisors out there, but some people don't feel comfortable talking to their advisors. Or they don't think they have big enough questions to go to (their academic advisors) to ask. And that's where your big sister can come in and offer advice about little things that the first year students don't think are that important."

The faculty/student events that *Women@SCS* have organized have also provided opportunities for Committee members to make personal connections with potential mentors and role models: "I've gained so much exposure to stuff just by listening to the grad students talk about their projects, meeting the faculty at the dinners."

- *Advice:* Be it professional or personal, Committee members have also turned to each other for advice, and meetings have provided a wonderful forum for informal advice sessions, as this student noted, "It's just been invaluable learning from their experiences, they're giving you a heads-up." This student said: "When I was really confused about how I should start getting internships or where should I start, there were a lot of girls who were going through the same things as I was and everyone had a different perspective, different advice on how to approach it and it helped a lot to discuss strategies."

- *Confidence and leadership skills:* Being a committee member played a role in improving at least one Committee members' confidence: "It helped my confidence in the sense that I saw that other people were having the same problems and so it wasn't just me." Taking responsibility for organizing events helped with their organizing skills and having leadership opportunities. Indeed, two students became teaching assistants as a direct result of encouragement from more senior *Women@SCS* Committee members. This woman explained, "for example, the class that I [work as a teaching assistant for], I wouldn't have taken it if I hadn't met [another Committee member] who [served as the teaching assistant] before me and told me oh you would love this class. You should take it. And it's one of the highlights of my whole academic career here."

- *Professional opportunities:* Invited industry visitors have provided personal contacts and recommendations that students may not have had otherwise: "Actually, I once got an internship just based on a speaker that came to talk to us." At one event this woman "took like pages of notes and I looked them over before I started my job search." Committee members have also been encouraged to attend and present at conferences, and *Women@SCS* has funded many conference attendees. Such opportunities are rare for undergraduate students generally. For one woman, attending the Grace Hopper conference had been a memorable experience: "That was an incredible experience. Just meeting again professionals in industry, meeting educators, other women who've been through tougher roadblocks than we have, kind of paved the way for us. That was incredible."

- *Social:* Committee members formed very close friendships and *Women@SCS* meetings connected women from different years who may not have met otherwise, as this student explains:

 I'm always learning from the girls, but it's just been a very close network of friends I've had that, maybe I wouldn't have really met otherwise. Some of the girls we're not in the same classes, or we're not pursuing the same track, and if it wasn't for this group I don't think I would have met them. Or even if I had met them in a class, it wouldn't really be the same. Here in the group you're more free to talk about your interests and what you like to do.
 – Female Senior, Class of 2004

- *Outreach:* Several Committee members had taken part in the annual Expanding Your Horizons[73] workshops for middle-school girls. But the pride and joy of this group was the Outreach Roadshow, which was started by students from the class of 2004, and has been developed further by later students. This student explained her sense of ownership:

 My biggest contributions though have been through the Roadshow which actually I guess, I don't want to say I'm a founding member of the Roadshow, but I am [laugh]. Just like the other three girls. It just came from one presentation. I was one of the people who did that presentation, so I kind of feel like it's our little baby, you know the Roadshow [laugh].
 – Female Senior, Class of 2004

Another student pointed out the value that the Roadshow might have to young audiences:

> I think the Roadshow is very worthwhile, just because I can picture myself, in the kids' shoes. . . . I feel like we're helping out the kids, just sort of showing them the interesting aspects of computer science, showing them what they can do with it, and how computer science is in everyday life, and sort of teach them a few things.
> – Female Senior, Class of 2004

We found that as students prepared their Roadshow presentations they also learned more about the field themselves and were then able to teach others: "It's just given me a lot more exposure to the different areas of computer science."

- *General:* This student explained the value of being a Committee member:

> I think it's really important to be on an advisory board if you want to have an active part in *Women@SCS*. It's also where you're going to get the most out of all the interactions. . . . We have weekly meetings and it's a good down time to talk with all the other girls and all the advisors. . . . It's also important to have input into all the programs and sessions we provide.
> – Female Senior, Class of 2004

Summary

The *Women@SCS* students who participate in the outreach opportunities described above enjoy their fields of study and want to share their enthusiasm and skills, knowing that few girls and women are exposed to the excitement of CS and/or creative technologies. This understanding inspires their efforts. The students who initiated the Roadshow did so with the aim of challenging and diversifying current images of computing-related fields and those who work and study in them. The student who initiated TechNights did so because she saw a need to increase opportunities for providing hands-on experiences and skills to girls and young women. As women they did not see themselves fitting naturally into the stereotypical images dominated by "geeky guys" but, perhaps more importantly, as students of CS, they did not see images of the field that matched their learning and exposure to an exciting field of study with so many possibilities.

Through the combined efforts and dedication of faculty and students, *Women@SCS* has proven itself to be an effective and valued organization within the School of Computer Science. The organization has strived to become a respected, action oriented, community-building organization working to improve the quality of the school experience for *all* students. *Women@SCS* has benefited from taking a cultural perspective on the student experience. This has meant offering a balance of opportunities for those in the minority, but also taking a broader view of how *Women@SCS* might benefit the student body as a whole, and the department in general. Some of the impetus for taking a broader perspective came from the *Women@SCS* Committee, whose members, rather than feeling driven by any sense of a gender divide, recognized that many of the events and activities planned for the women had the potential to benefit all. As the gender divide has lessened a move towards mutual concerns and benefits has emerged. In this way *Women@SCS* has contributed to the changing culture within the department.

Our goal has been to foster a community that promotes academic success and professional growth, one that will benefit women in CS as well as the community-at-large. Most importantly we promote *academic* success not through curriculum changes but by providing essential networking and mentoring along with social and professional opportunities.

> I really feel that *Women@SCS* has supported me throughout all of my college career, whether or not I've been an "active" member. My first year, I met a Ph.D. at a *Women@SCS* lunch event who I went on to do research with. She encouraged me to enter a poster competition at a research conference. In my sophomore year, I became a lot closer with several members of *Women@SCS*. Not only were the friendships very rewarding on a personal level, but the women helped me with my goal of putting on SCS Day. [Another member] created the entire budget from several emails, and [another member] auditioned for and opened the talent show. Now in my junior year, me and the other upperclass students are getting excited about making *Women@SCS* an even more fantastic resource.
> – Female Junior, Class of 2014

We endeavor to view problems as challenges to be tackled in creative and constructive ways. An active *Women@SCS* Committee has enabled us to

offer many events and activities to improve the professional and social environment for women in CS. With good organization, faculty, and administrative support and commitment, a student organization with a *Committee* at the helm, will provide the talent, energy and innovative ideas to lead the way.

CHAPTER 7

Conclusion: From Difference to Diversity

For years, NSF has been working to engage students from under-represented groups at all levels, so that those with STEM degrees and in STEM careers can truly be reflective of our diverse society. We also cannot afford not to harness the talent of people from all groups in the STEM enterprise. Diversity of our STEM workforce is critical, especially as it relates to the changing demographics of the nation and the increasing competition in the global marketplace.

– Carnegie Mellon President Subra Suresh, July 2011[74]

A Call to Action

The past two decades have been plagued by a persistent disparity in the recruitment and retention of women in computing. In this book, we explored the many considerations and reasons for why this might be. In our discussion we hope we have provided a convincing argument that alternative ways of thinking about, and acting on, gender and CS issues could benefit both the field and the people in it. We have argued for the examination of *variables outside of gender* as possible sources of differences in women's participation in CS. In particular we have suggested, and illustrated, *a cultural approach*, a specific approach, which pays close attention to culture and environment, noting the factors that can allow for, or hinder, women's participation.

Our work has also led us to conclude that all too often student attitudes about CS are not well represented when seen through the lens of a gender dichotomy. A more robust understanding of the issues can be revealed through a prism-like view of the spectrum of attitudes among people—regardless of gender. Indeed, we should not close our eyes to the bigger and more complex picture which often reveals gender similarities, the dynamic interactions of people and topics within the field of CS, and recognizing "that people's behavior today is determined more by situation than by gender" (Barnett and Rivers, 2005). This shift in focus is consistent with many prominent researchers (e.g., Epstein, 1988; Huang and Trauth, 2010; Joshi et al., 2010; Kanter, 1977; Kvasny et al., 2009; Trauth, 2011a, 2011b). We believe now is the time for new strategies and new ways of framing how we think about broadening participation in CS. In writing this book we do not claim to have found a

one-stop solution but we believe we have a role to play in changing the broad conversation about women in computing.

The Power of Culture

As we have previously acknowledged, a multitude of determinants—biological, educational, psychological, economic, cognitive, social, etc.—are involved in anybody choosing or not choosing to do something. Also, as we noted earlier we cannot hope to unravel them all to get at the "right" factors. Nevertheless, our position in this book has been selective—we acknowledge our bias in focusing on culture.

We have become a culture of pink and blue; and it's tough to avoid. We are constantly steered—and steering our children—in the direction of social and market driven gender norms. But having said that how many of us actually think of this in terms of "gender steering" as opposed to thinking this is just normal; after all aren't boys and girls so very different? The dominant culture of the United States is entrenched with gender difference beliefs. Yet, researchers from the field of neuroscience are uncovering more and more evidence to challenge the notion of hard wiring; our brains are much more plastic than we have come to believe. Cordelia Fine (2010) argues that so much of what we have come to believe about the brain is neurosexism creating differences where none may exist. In reality "our brains, as we are now coming to understand, are changed by our behavior, our thinking, our social world" (p. 176-177). In the United States the gender divide starts early: "what is perhaps most striking in today's world is that parents continue to stereotype their infants, beginning even before they are born" (Eliot, 2009, p.102).

While the gender divide is not confined to the United States it does not always show itself in a culture of "Pink Brain, Blue Brain." This is often brought home to us in conversations with female international students (we have heard anecdotes from students who grew up in Morocco, Iran, Romania, Bulgaria, Venezuela, India[75]) now studying in the School of Computer Science. We frequently hear how their early experiences relating to intellectual and academic expectations differ from those of girls growing up here. The international students are often baffled—at first!—by why we would need programs like *Women@SCS* to encourage and help sustain women in computing fields. It never occurred to them as they were growing up that they could not study or be successful in math/science/computing fields or any academic field for that matter. The point we want to emphasize is that what is happening in the United

States and many parts of the western world—with so many girls growing up to believe they do not fit the field of computing—is not universal.

The Good News—Culture is Mutable

One of the major reasons for focusing on culture is that culture is mutable, and our actions can effect positive change; especially in environments where we have some control over both the demographics, and the opportunities we offer.

We suggest that the *different and/or similar* ways in which students relate to computing, are in large part the product of a specific culture and environment, and are not produced by any intrinsic distinctions between men and women. This is good news in terms of working for change. Many recommendations to decrease the gender bias and barriers that women face require universities and their leaders to pay attention to "workplace environments" and to "changing the culture and structure of their institutions to recruit, retain, and promote more women—including more minority women—into faculty and leadership positions" (National Academies Press Release, 2006).

Our readers should know that our recommendations to look at factors outside of gender differences are not new. Many researchers have made similar suggestions and while not specific to CS their work is applicable in many ways. As mentioned above Cordelia Fine and Lise Eliot question gender differences through their neroscientific expertise. In her classic 1970s work examining the attitudes and behaviors of men and women in a large corporation (the Industrial Supply Corporation or Indsco),[76] Rosabeth Kanter (1977) concluded that the systems in place which determine social dynamics and differences, *are opportunity and power related*, not gender based. She argued that three primary variables—power, opportunities, and numbers—determine social dynamics, not gender. In the 1980s, Cynthia Fuchs Epstein made a similar observation:

> Over the past two decades, women have clearly demonstrated competence in spheres in which it was once believed they had no interest and no qualifications. This success demonstrates how opening **the opportunity structure** [emphasis added] has developed their interest and ambition (Epstein, 1988, p. 164).

Epstein (1988) suggests "it is easier to propose dichotomy than to explicate the complexities that make them invalid" (p. 15). It is this

dichotomy that seems to have taken hold on dominant cultures in the western world. In their book *Occupational Ghettos: The Worldwide Segregation of Women and Men*, Maria Charles and David Grusky explore the potential harm of gender difference beliefs to women in the workplace. They argue that *essentialism* is still entrenched in the dominant culture, and even if we no longer believe that men are *better* than women, we still subscribe to a belief that men and women are *very different*. They add that this persistent belief in difference affords two outcomes: employers to assign men and women to different jobs and to induce workers to come to want those different jobs. Charles and Grusky suggest this is most prevalent in advanced industrial countries where a deep-seated belief in gender differences is maintained and supported by a belief in individual preferences.

Strategies for Action

In an ideal world we would all have terrific institutional support for our efforts to broaden participation in CS whether in industry or academia. But we know this is far from the norm. However, we also feel there are some actions that many of us can take, particularly those which employ human resources—the most valuable resource of all—especially in situations where we have some control.

One of the areas we can try to address is that of perceptions of CS. For example, spreading awareness of careers in the field, what computer scientists actually do, the kind of classes that students take, can all help in broadening understanding of CS. In order to change the perceptions of CS middle school and high school girls (and boys) it is vital to change the perceptions of the adults who have responsibility for them—parents/guardians, teachers, school counselors. Parents, in particular, are often (if not always) left out of strategies for broadening participation in computing and yet they are a critical group to reach. A British study of the perceptions of computing careers among high school students found (to the surprise of the researchers) that the major influences were—in this order—their parents, next the media and then someone who already works in the field (McEwan and McConnell, 2013). Therefore, we encourage readers to take an active role in reshaping perceptions of computing to show a field in which both boys and girls can aspire.

Shelley Correll, Stanford University professor and the Director of the Clayman Institute for Gender Research suggests that stereotypes, and the bias they support, may be a major reason that gender equity has stalled

after many years of progress.[77] Raising awareness of bias, and increasing understanding of how stereotypes function, represent the first steps to limiting bias. These are important steps since gender bias (unconscious bias in particular) can have an impact on life choices. Indeed, research has shown that the relationship between gender and perception can be particularly critical for women. One of the first studies to illustrate this was when the number of positions offered to women in some of the major orchestras was shown to increase dramatically when the auditions were blind; in this case auditions were done behind a screen (Goldin and Rouse, 2000). We can also play a role in challenging stereotypes more generally. As consumers we can speak our mind with our wallet—purchasing toys, clothes and media that do not conform to male/female stereotypes. But whether we challenge stereotypes or let our kids be "pink princesses" and "Darth Vadors" we must ensure they are not defined and limited by these images; especially in terms of their academic potential.

As professionals we can debunk and challenge stereotypes in the classroom and boardroom. For universities and organizations developing and implementing interventions to improve the representation of women, it is important to reexamine the diversity discourse to understand how it can be reached from multiple integrated perspectives. For example, we should include in our consideration not only demographic differences between men and women, but also socio-cultural factors. Consistent with this premise, our work has found that gender, alone, is not a determining factor as to why women pursue opportunities in CS. Rather it is a combination of many factors including their social shaping and thus these considerations should be kept at the forefront of decisions about program offerings and interventions. Building an inclusive environment is based on welcoming a range of perspectives rather than expecting conformity.

We are great believers in grassroots efforts. Outreach to fellow students, to employees, to local K-12 students and teachers, can be as simple as a conversation about careers in computing or a presentation by one or two people. Conversations in industry can help spread the message that diverse perspectives have been shown to improve business models, all the better to appeal to multiple buyers from a broader customer base. Outreach by our School of Computer Science students have proven to be one of the most effective strategies for bringing students not involved in "women's issues" into the conversation; we have found many who are eager to do outreach and spread the word about CS. In return, the

rewards for these students are great whether it's teaching as a means of learning, improving public speaking skills, confidence building, networking, and simply having fun with fellow students.

While we wait impatiently for changes at the policy level many grassroots action-oriented programs like Carnegie Mellon's *Women@SCS* are helping to sustain communities of women in universities, in high schools, and in industry while also developing outreach programs to spread the word about CS to future generations. In schools where the numbers of women are few, students can still take advantage of the many resources now available to help them develop their own communities and organizations. As we have shown such action can promote the value and visibility of women and benefit themselves and their peers.

Various organizations offer free online resources providing data and opportunities we can use to help with our efforts. The Anita Borg[78] Institute's Grace Hopper Celebration of Women in Computing Center is now famous worldwide and supports local area celebrations. The National Center for Women and Information Technology[79] works with academia and industry to promote gender equity in information technology and computing at both the policy level and locally. NCWIT's National Aspirations in Computing Awards program recognizes high school girls for their efforts in computing at both national and local levels. Other well-known organizations noted for their efforts, *but by no means all*, include the Association for Machinery's Women in Computing Committee ACM-W[80]) and Women in Computing Research (CRA-W[81]). Research and action-based programs are being promoted and encouraged by the National Science Foundation (NSF) (e.g. the Advance[82] and STEM-C Broadening Participation Awards[83]). Other organizations work broadly on diversity and inclusion, for example, the national Center for Minorities and People with Disabilities in Information Technology[84] (CMD-IT) and the AccessComputing Alliance[85] which works to increase the participation of people with disabilities in computing fields. There are also many other programs[86] not specifically related to computing that are working to ensure that opportunities and resources in math and science are made available to girls and women.

In designing strategies for change, we have proposed that it makes sense to take a global perspective, looking at those environmental and cultural conditions that enable the Women-CS fit. The lead for this direction is already emerging from industry as nations compete in the world market, and more and more companies are finding it imperative to pay attention

to the micro-cultures within their organizations. It is being argued that future business successes will be found where the company culture allows for a well-managed diverse workforce and diverse leadership teams. Business reports are making the business case for having more women in the science and technology workforce: "Nowadays, the focus has changed from moral-justice reasons to hard economic evidence" (European Commission, 2006, p. 19). Many companies are also now developing outreach initiatives to help broaden participation in computing, change people's perceptions of the field and/or encourage young students to learn to code. For example, the non-profit organization, Code.org[87], developed Hour of Code, an online initiative to teach kids to code, has proven very successful and easily adoptable as an outreach effort in schools and homes.

Cultural Change at Carnegie Mellon University

The many positive changes in the micro-culture of the School of Computer Science at Carnegie Mellon have shown that a more diverse student body, including increased numbers of female students, has enriched the social and academic environment for *everyone*. While there is still more work to be done for, and beyond, gender diversity we believe the Carnegie Mellon journey offers an exemplar case study of the many issues surrounding gender and CS.

By 2002 we had observed that women appeared to be thriving in Carnegie Mellon's School of Computer Science in sharp contrast to earlier observations. Arguably such changes could not have occurred if the gender differences found in the 1990s research existed at any deep-rooted, meaningful level. So what had changed? After all, as Lenore Blum points out, the women coming into the CS major were still women—we did not change women! But we did change their environment. Snapshot studies to examine what had changed (2002 and 2004) were followed by continued observations of the Women-CS fit and by further studies (2009-2010 and 2011-2012). These studies revealed many gender similarities and a spectrum of attitudes towards CS showing that an inclusive culture still prevails and that the Women-CS fit has been sustained without accommodating presumed gender differences.

We also hope the Carnegie Mellon story of women in computing can help challenge the gender divide in CS and encourage, and inspire, parents, teachers, and students to think more broadly about intellectual and academic expectations.

Problematic Gender Generalizations

Our findings from studies at Carnegie Mellon advise caution in generalizing from the attitudes of women in minority situations (e.g. where there is no critical mass) to women in general. We advise this because almost everything we've come to believe about women and computing (and men and computing) is derived from examining situations where there are either relatively few women participants or single sex situations. Generalizing from such findings can be misleading if we attribute specific attitudes to women when in fact such attitudes can change as the situation changes. Clearly, as Kanter pointed out, numbers are *a source* of difference. Of course we do not claim that numbers are the only important factor. Indeed, among other factors we have shown how the establishment of *Women@SCS* helped ensure that women had opportunities for leadership, for creativity, for networking and for impacting the whole school. However, at Carnegie Mellon we were able to see the impact of changes in numbers—when women reached critical mass we saw changes in attitudes, in culture and in sense of fit.

Perhaps the most significant change we found related to students' deepening understanding of the scope of CS. The idea that programming pretty much defined the field led to the early gender distinctions that categorized women as "computing with a purpose" and men as "dreaming in code." But what we found in our studies was that almost *all students* reported programming as *one part* of their CS interests, and they viewed programming as a *tool* for developing *applications*—frequently their primary motivation for being in the field. CS had come to mean a challenging and complex field requiring multiple skill sets and diverse interests. This is a significant difference from the general public's view of CS where stereotypes persist and where CS is narrowly viewed as "computer programming by male nerds."

Another particularly significant finding is that the attitudes and experiences of the women in our cohorts were not static; they became more and more positive as they progressed through the program. We attribute this outcome not only to their increasing academic ability and skills but also, in part, to their own contributions as they help shape the environment and computing culture for the benefit of everyone.

Beyond Carnegie Mellon University

The culture of a school is largely determined by its members and by the direction of its leadership. Carnegie Mellon is top-ranked in CS, has rich

resources in terms of faculty and academic programs, and has several thousand applications (over 6000 in 2014) for a maximum 150 places in the CS major. This situation, along with its broad admissions policy, helps ensure that the CS major includes a critical mass of smart young women many of whom have strong leadership potential, and thus the potential to impact the culture of the school alongside their male peers. The school also has leadership committed to diversity and provides line-item resources to ensure that women do not miss out on opportunities that ensure their engagement in CS and in the school. Our deans in the School of Computer Science from Raj Reddy, to James Morris, and for the past 10 years, Randy Bryant, have supported our efforts on many levels. Their steady leadership and innovative thinking also set the tone for other faculty and staff who have contributed to building a helpful, collaborative—and fun!—environment. The new Dean of the School of Computer Science, Andrew Moore, has been on the School of Computer Science faculty since 1993 but also led Google Pittsburgh to great heights from 2006-2014. Andrew took up his position as Dean of the School of Computer Science in August 2014 and has already started working with Carol and *Women@SCS*. Without this community we probably could not have gone forward with our work to engage and retain women in CS.

Some researchers and practitioners believe the best approaches for increasing women's participation in CS are those that focus on developing a curriculum based on what are thought to be the interests of women (e.g., Rich et al., 2004[88]). One of the most popular driving forces is based on making CS courses meaningful and relevant to the lives of students, so that the curriculum is designed around problems they can relate to.[89] This has *not* been the direction of Carnegie Mellon but until women are well represented in CS across the nation, it makes sense that researchers, educators, and gender equity organizations will explore approaches that show signs of success. This book represents our attempt to offer what we believe is the most effective approach, one which takes a broad perspective on the culture and environment of the school without accommodating what are perceived to be "women's" learning styles and attitudes to CS.

> Thus, while the need and methodology for change might be motivated by the interests and needs of an under represented group, it is our view that, for programs to succeed and become part of the institutional fabric, ultimately they must mesh with the sensibilities of the institution, even serve to enhance the enterprise in general. (Blum and Frieze, 2005b, p. 14)

Support for our argument has been drawn from a variety of sources, including evidence from psychology and education research, from research on stereotypes, evidence from gender similarities research, from the world of business, and evidence from other cultures and countries. In sum, we have proposed, and shown evidence to support, the value of paying attention to culture and environments.

What educational researchers are finding, not surprisingly, is that "interventions that are better for women are also better for men."[90] While approaches to broadening participation in CS may differ, we have several elements in common: close attention to the issue, recognition that women fit the field of CS, institutional support, a willingness to act and flexibility to enable change.

Future Efforts—*From Difference to Diversity*

Gender difference approaches have not provided satisfactory explanations for the low participation of women in CS and beliefs in a gender divide may deter women from seeing themselves in male dominated fields. We strongly believe that without due caution the search for gender differences can work against diversity and inclusion efforts, while perpetuating stereotypes and further marginalizing women.

At least in the field of CS, it seems counterproductive to think in terms of deep-rooted and/or biologically determined aptitudes between men and women. At its extreme this would mean a CS for women and one for men!

If our aim is to increase diversity in CS we need to move beyond old models and perceptions which continue to represent men and women as two distinct categories with either a male or a female view on CS and no reference to the context or situation in which such views are formed. The idea that men are not interested in the broader applications of CS and that women do not like programming has become an outdated cliché. All men and women have the *potential* to be multi-dimensional—capable of spanning genders through a spectrum of perspectives—as they discover and respond to the exciting field of CS studies and the environments in which they work and socialize.

Our Carnegie Mellon case studies illustrate how well thought-out interventions in the environment, interventions that are inclusive and take all students into account, rather than changing the academic curriculum,

can allow for diversity, opening the way for women to contribute and be successful in computing fields. This kind of participation is embodied in the Women-CS fit that has evolved at Carnegie Mellon and in the organization *Women@SCS* that works to change the perception of CS through outreach while providing leadership opportunities for women to develop programs that benefit themselves, their peers and the university. *Women are kicking butt in CS at Carnegie Mellon alongside, their male peers!*

We have been able to show that a micro-culture can change; shaping and being shaped by students' attitudes and actions. The School of Computer Science moved towards a more "balanced" environment: balanced in terms of gender (including a critical mass of women), in terms of the range of student personalities and interests, and in terms of increased opportunities for all—men and women. Most importantly we have shown that women can participate successfully in CS without resorting to traditional "female-friendly" strategies or curriculum changes to accommodate what are perceived to be the interests of women. Such strategies can carry with them the suggestion that women need academic handholding. Indeed, we have cautioned against interventions, which accommodate gender differences, especially when gender differences can dissolve under certain conditions. In the long term such interventions may work against women, marginalizing their intellectual opportunities and ultimately perpetuating a gender divide.

As we have illustrated, data show that many students in the United States, especially women and minorities, are never exposed to computing and/or are not encouraged to see themselves in the field. Indeed, in conversations with teachers and high school students we found very little had changed since the late 1990's when Margolis and Fisher heard teachers lament the low representation of girls in their CS classes. Now, more than 15 years on, we still have much work to do in terms of developing a K-12 CS curriculum, in terms of teaching CS skills, in terms of informing students, teachers, and families about career opportunities, in terms of changing perceptions of computing, and in terms of showing that the field of computing can fit a diverse range of people. The inequity in representation and participation in computing often disadvantages those most disadvantaged already by inequities in society. Meanwhile many lucrative and interesting job opportunities in computing in the United States go unfilled. The repercussions can be very serious for individuals and for the nation. But we hope to have shown that this situation is not so mysterious nor such an intractable problem.

We conclude with a new story of diversity developments at Carnegie Mellon, one that has yet to unfold but which makes a fitting conclusion to our story of women in computing at Carnegie Mellon. In the fall of 2013, a new initiative was launched in the School of Computer Science: the organization SCS4*ALL*.[91] The SCS4*ALL* Advisory Committee is an umbrella organization that works to develop a program of social and professional activities and leadership opportunities to broaden interest and participation in computing by under represented groups including women, minorities, students and teachers in K-12, people with disabilities, and those who may feel isolated or left out. The goals of SCS4*ALL* are twofold: to foster community building that promotes diversity in Carnegie Mellon's School of Computer Science and to lead outreach efforts to broaden interest, understanding and diversity in computing fields more generally. *Women@SCS* was asked to take the lead in this new organization, an exciting next step in their leadership initiatives. We see this as an important step in the story of women in computing at Carnegie Mellon and in the transition of our actions and thinking as we continue to advance *from difference to diversity.*

References

Adams, J., Vimala, B., and Baichoo, S. (2003). "An Expanding Pipeline: Gender in Mauritius." *Proceedings of the 34th ACM SIGCSE Technical Symposium on Computer Science Education*, 59–63.

Alvarado, C., Dodds, Z., and Libeskind-Hadas, R. (2012). "Increasing Women's Participation in Computing at Harvey Mudd College." *ACM Inroads*, 3(4), 55-64.

American Association of University Women (AAUW). (1991). *Short-changing Girls, Shortchanging America*. Washington, D.C.: Researched by Greenberg-Lake: The Analysis Group. Retrieved from http://www.aauw.org/files/2013/02/shortchanging-girls-shortchanging-america-executive-summary.pdf

Arora, S., and Chazelle, B. (2005). "Is the Thrill Gone?" *Communications of the ACM*, 48(8), 31-33.

Babbie, E. (2004). *The Practice of Social Research (10th Edition)*. Thomson Learning Inc.: Wadsworth: Belmont, California.

Bails, J. (2008, July). "Role Models." *Carnegie Mellon Today*, 5(3), 24.

Barker, L., and Garvin-Doxas, K. (2004). "Making Visible the Behaviors That Influence Learning Environments: A Qualitative Exploration of Computer Science Classrooms." *Computer Science Education*, 14(2), 267-273.

Barnett, R. and Rivers, C. (2005). *Same Difference: How Gender Myths are Hurting Our Relationships, Our Children, and Our Jobs*. New York, New York: Basic Books.

Baumeister, R., and Leary, M. (1995). "The Need to Belong: Desire For Interpersonal Attachments as a Fundamental Human Motivation." *Psychological Bulletin*, 117, 497–529.

Beyer, S., Chavez, M., and Rynes, K. (2002, May). "Gender Differences in Attitudes toward and Confidence in Computer Science." *Proceedings of the Annual Meeting of the Midwestern Psychological Association*, Chicago, Illinois.

Beyer, S., Rynes, K., and Haller, S. (2004). "Deterrents to Women Taking Computer Science Courses." *IEEE Technology and Society Magazine,* 23(1), pp. 21-28.

Beyer, S., Rynes, K., Perrault, J., Hay, K., and Haller, S. (2003). "Gender Differences in Computer Science Students." *Proceedings of the 34th ACM SIGCSE Technical Symposium on Computer Science Education,* 49-53.

Blum, L. (2004). "Women in Computer Science: The Carnegie Mellon Experience." In Resnick, D., and Scott, D.S. (Eds.). *The Innovative University.* Pittsburgh, Pennsylvania: Carnegie Mellon University Press.

Blum, L. (2001). "Transforming the Culture of Computing at Carnegie Mellon." *Computing Research News,* 13(5), 2.

Blum, L., and Frieze, C. (2005a). "In a More Balanced Computer Science Environment, Similarity is the Difference and Computer Science is the Winner." *Computing Research News,* 17(3), 2-16.

Blum, L. and Frieze, C. (2005b). "The Evolving Culture of Computing: Similarity is the Difference." *Frontiers: A Journal of Women Studies, Special Issue on Gender and IT,* 26(1), 110-125.

Blum, L., and Givant, S. (1980). "Increasing the Participation of Women in Math-Based Fields: A Collegiate Program." *American Mathematical Monthly,* 87(10).

Brescoll, V. (2011, January). "What Do Leaders Need to Understand about Diversity?" *Yale Insights.* Retrieved from http://insights.som.yale.edu/insights/what-do-leaders-need-understand-about-diversity

Carroll, A.B., and Shabana, K.M. (2010). "The Business Case for Corporate Social Responsibility: A Review of Concepts, Research and Practice." *International Journal of Management Reviews,* 12(1), 85-105.

Charles, M., and Grusky, D. (2005). *Occupational Ghettos: The Worldwide Segregation of Women and Men (Studies in Social Inequality).* Redwood City, California: Stanford University Press.

The Chartered Institute of Personnel Development (CIPD). (2006). "Managing Diversity, Measuring Success." London, United Kingdom. Retrieved from http://www.cipd.co.uk/hr-resources/research/managing-diversity-measuring-success.aspx.

Cheryan, S., Plaut, V.C., Davies, P.G., and Steele, C.M. (2009). "Ambient Belonging: How Stereotypical Cues Impact Gender Participation in Computer Science." *Journal of Personality and Social Psychology,* 97(6), 1045-1060.

Cohoon, J. McGrath, and Aspray W. (2006) *Women and Information Technology.* Cambridge, Massachusetts: MIT Press.

Cuny, J., and Asprey, W. (2000). "Recruitment and Retention of Women Graduate Students in Computer Science and Engineering: Results of a Workshop Organized by the Computing Research Association." San Francisco, California, June 21-22, 2000.

Dean, C. (2007, April 17). "Computer Science Takes Steps to Bring Women to the Fold." *The New York Times.* Retrieved from: http://www.nytimes.com/2007/04/17/science/17comp.html?pagewanted=print&_r=0

Deloitte. (2011, September). "Only Skin Deep? Re-examining the Business Case for Diversity." *Deloitte Point of View.* Retrieved from https://www.ced.org/pdf/Deloitte_-_Only_Skin_Deep.pdf

Dunning, D., Johnson, K., Ehrlinger, J., and Kruger, J. (2003). "Why People Fail to Recognize Their Own Incompetence." *Current Directions in Psychological Science,* 12(3), 83-87.

Eglash, R. (2002). "Race, Sex, and Nerds: From Black Geeks to Asian American Hipsters." *Social Text,* 20(2), 49-64.

Eliot, L. (2009). *Pink Brain Blue Brain.* New York, New York: Houghton Mifflin Harcourt.

Epstein, C.F. (1988). *Deceptive Distinctions: Sex, Gender, and the Social Order.* New Haven, Connecticut: Yale University Press.

Etzkowitz, H., Kemelgor, C., and Uzzi, B. (2000). *Athena Unbound: The Advancement of Women in Science and Technology.* Cambridge, United Kingdom: Cambridge University Press.

European Commission. (2005). "The Business Case for Diversity: Good Practices in the Workplace." Brussels, Belgium. Retrieved from http://ec.europa.eu/research.

European Commission. (2006). "Women in Science and Technology – The Business Perspective." Brussels, Belgium. Retrieved from http://ec.europa.eu/research/science-society/pdf/wist_report_final_en.pdf

European Commission (2008). "Women in Industrial Research." Brussels, Belgium. Retrieved from http://ec.europa.eu/research/science-society/women/wir/pdf/wir-best-practice_en.pdf

Fine, C. (2010). *Delusions of Gender.* New York, New York: W.W. Norton and Company.

Fox, M.F. (2000). "Organizational Environments and Doctoral Degrees Awarded to Women in Science and Engineering Departments." *Women's Studies Quarterly,* 28 (1 & 2), 47-51.

Frieze, C., and Blum, L. (2002). "Building an Effective Computer Science Student Organization: The Carnegie Mellon Women@SCS Action Plan." *ACM SIGCSE Bulletin – Women in Computing,* 34(2), 74-78.

Frieze C., Hazzan, O., Blum L., and Dias, B. (2006) "Culture and Environment as Determinants of Women's Participation in Computing: Revealing the 'Women-CS Fit.'" *Proceedings of the 37th ACM SIGCSE Technical Symposium on Computer Science Education,* 22-26.

Frieze C., and Quesenberry, Q. (2013). "From Difference to Diversity: Including Women in the Changing Face of Computing." *Proceedings of the 44th ACM SIGCSE Technical Symposium on Computer Science Education,* 445-450.

Frieze C., Quesenberry, Q., Kemp, E., and Velaszquez, A. (2011). "Diversity or Difference? New Research Supports the Case for a Cultural Perspective on Women in Computing." *Journal of Science Education and Technology,* 21(4), 423-439.

Frieze, C., and Treat, E. (2006). "Diversifying the Images of Computer Science: Carnegie Mellon Students Take on the Challenge." *Proceedings of the 2006 WEPAN Conference.* Retrieved from http://www.cs.cmu.edu/~cfrieze/talks/WEPAN.pdf.

Galpin, V. (2002). "Women in Computing Around the World." *ACM SIGCSE Bulletin – Women in Computing,* 34(2), 94-100.

Goldin, C., and Rouse, C. (2000). "Orchestrating Impartiality: The Effect of 'Blind' Auditions on Female Musicians." *American Economic Review,* 90(4), 715-741.

Gray, J. (1992). *Men are from Mars, Women are from Venus.* New York, New York: HarperCollins.

Gurer, D. (2002). "Pioneering Women in Computer Science." *ACM SIGCSE Bulletin – Women in Computing,* 34(2), 120.

Halpern, D. (2000) *Sex Differences in Cognitive Abilities.* Lawrence Mahwah, New Jersey: Erlbaum Associates.

Hazzan, O. (2006). "Diversity in Computing: A Means or A Target?" *System Design Frontier Journal,* 8.

Humphreys, S. and Spertus, E. (2002). "Leveraging an Alternative Source of Computer Scientists: Reentry Programs." *ACM SIGCSE Bulletin – Women in Computing,* 34(2), 53-56.

Huang, H. and Trauth, E.M. (2010). "Identity and Cross-cultural Management in Globally Distributed Information Technology Work." *Proceedings of the International Conference on Information Systems,* St. Louis, Missouri.

Huyer, S. (2005). "Women, ICT and the Information Society: Global Perspectives and Initiatives." *Proceedings of the International Symposium on Women and ICT: Creating Global Transformation* (CWIT '05), New York, New York: ACM.

Hyde, J.S. (2005) The Gender Similarities Hypothesis, *American Psychologist,* 60(6), 581-592.

Hyde, J.S., and Linn, M.C. (2006). "Gender Similarities in Mathematics and Science." *Science,* 314(5799), 599-600.

Irani, L. (2004). "Understanding Gender and Confidence in CS Course Culture." *ACM SIGCSE Bulletin,* 36(1), 195-199.

Jackson, L.A., Gardner, P.D., and Sullivan, L.A. (1993). "Engineering Persistence: Past, Present, and Future Factors and Gender Differences." *Higher Education,* 26, 227-246.

Joshi, K.D., Kvasny, L., McPherson, S., Trauth, E.M., Kulturel-Konak, S., and Mahar, J. (2010). "Choosing IT as a Career: Exploring the Role of Self-efficacy and Perceived Importance of IT Skills." *Proceedings of the International Conference on Information Systems,* St. Louis, Missouri.

Kanter, R.M. (1977). Moss. *Men and Women Of the Corporation.* New York, New York: Basic Books.

Kay, K., and Shipman C. (2014, April 14). The Confidence Gap. *The Atlantic.* Retrieved from http://www.theatlantic.com/features/archive/2014/04/the-confidence-gap/359815/

Kumar, D. (2011). "Ready for a Third Peak?" *ACM Inroads,* 2(3), 10-11.

Kvasny, L., Trauth, E.M., and Morgan, A. (2009). "Power Relations in IT Education and Work: The Intersectionality of Gender, Race, and Class." *Journal of Information, Communication & Ethics in Society, Special Issue on ICTs and Social Inclusion,* 7(2/3), 96-118.

Larsen, E.A., and Stubbs, M.L. (2005). "Increasing Diversity in Computer Science: Acknowledging, Yet Moving Beyond, Gender." *Journal of Women and Minorities in Science and Engineering,* 11(2), 139-170.

Lazowska, E. (2010). "Where the Jobs Are..." *Computing Community Consortium (CCC) Blog.* Retrieved from http://www.cccblog.org/2010/01/04/where-the-jobs-are

Lehman Brothers Centre for Women in Business. (2007). "Innovative Potential: Men and Women in Teams." *London Business School.* Retrieved from http://www.lnds.net/blog/images/2013/09/gratton reportinnovative_potential_nov_2007.pdf

Little, J.C., Granger, M., Adams, E.S., Holvikivi, J., Lippert, S., Walker, H.M., and Young, A. (2001). "Integrating Cultural Issues into the Computer and Information Technology Curriculum." *ACM SIGCSE Bulletin*, 33(2), 136-154.

Linn, M., and Hyde, J. (1989). "Gender, Mathematics and Science." *Educational Researcher*, 18, 17-27.

Lynn, L., and Salzman, H. (2007, July/August). "The Real Global Technology Challenge." *Change: The Magazine of Higher Learning*, 39(4), 11-13.

Mannix, E., and Neale, M.A. (2005). "What Differences Make a Difference? The Promise and Reality of Diverse Teams in Organizations." *Psychological Science in the Public Interest*, 6, 31-55.

Margolis, J., and Fisher, A. (2002). *Unlocking the Clubhouse: Women in Computing*, Cambridge, Massachusetts: MIT Press.

Margolis, J., Fisher, A., and Miller, F. (n.d.) "Geek Mythology." Retrieved from: http://www.cs.cmu.edu/afs/cs/project/gendergap/www/geekmyth.html

Margolis, J., Fisher, A., and Miller, F. (1999). "Caring about Connections: Gender and Computing." *Technology and Society Magazine, IEEE*, 18(4), 13-20.

Matlin, M. (1999). "Bimbos and Rambos: The Cognitive Basis of Gender Stereotypes." *Eye on Psi Chi* published by *the National Honor Society in Psychology*, 3(2), 13-14.

Maxwell, J.A. (1996). *A Qualitative Research Design: An Interactive Approach*. Thousand Oaks: California: Sage Publications.

McAward, T. and Raftery, M. (2012). "How to Find (and Keep) STEM Talent." *Kelly Outsourcing & Consulting Group*. Retrieved from http://www.kellyocg.com/Workforce_Trends/How_to_Find_STEM_Talent/#.VPnairPF9Cw

McCarthy, H. (2004). *Girlfriends in High Places: How Women's Networks are Changing the Workplace*. London, United Kingdom: DEMOS.

McEwan, T., and McConnell, A. (2013). "Young People's Perceptions of Computing Careers." *Proceedings of the 43rd Annual Frontiers in Education Conference*, Piscataway, New Jersey, 1597-1603.

McKinsey & Company, Inc. (2007). "Women Matter: Gender Diversity, A Corporate Performance Driver." Retrieved from http://www.raeng.org.uk/publications/other/women-matter-oct-2007

McKinsey & Company, Inc. (2008). "Women Matter 2: Female Leadership, A Competitive Edge for the Future." Retrieved from http://www.mckinsey.com/~/media/mckinsey/dotcom/client_service/organization/pdfs/women_matter_oct2008_english.ashx

McKinsey & Company, Inc. (2012, April 30). "Unlocking the Full Potential of Women at Work." A 2012 Special Report produced exclusively for the Wall Street Journal Executive Task Force for Women in the Economy by Barsh, J. and Yee, L.

McKinsey & Company, Inc. (2014, January). "Moving Mind-sets on Gender Diversity: McKinsey Global Survey Results." McKinsey Insights and Publications. Retrieved from http://www.mckinsey.com/insights/organization/moving_mind-sets_on_gender_diversity_mckinsey_global_survey_results

Melymuka, K. (2001, January 8). "If Girls Don't Get IT, IT Won't Get Girls." *ComputerWorld*. Retrieved from http://www.computerworld.com/s/article/55910/If_Girls_Don_t_Get_IT_IT_Won_t_Get_Girls_?taxonomyId=057.

Miller, C.C. (2011, June 10). "Computer Studies Made Cool, on File and Now on Campus." *New York Times*. Retrieved from http://www.nytimes.com/2011/06/11/technology/11computing.html

National Academies. (2006, September 18). "Broad National Effort Urgently Needed to Maximize Potential of Women Scientists and Engineers in Academia." National Academies Press Release. Retrieved from http://www8.nationalacademies.org/onpinews/newsitem.aspx?RecordID=11741

Orenstein, P. (1995). *Schoolgirls: Young Women, Self Esteem, and the Confidence Gap.* New York, New York: Anchor Book Editions.

Quesenberry, J.L. (2006). "Female Retention in Post Secondary Education." In Trauth, E.M. (Ed.), *The Encyclopedia of Gender and Information Technology*. Hershey, Pennsylvania: Idea Group Reference, 317-322.

Quesenberry, J.L., and Trauth, E.T. (2012). "Working Where She Wants and Wanting Where She Works: Understanding Career Values and Motivations of Women in the IT Workforce." *Information Systems Journal*, (22), 457-473.

Rich, L., Perry, H., and Guzdial, M. (2004). "A CS1 Course Designed to Address Interests of Women." *ACM SIGCSE Bulletin*, 36(1), 190-194.

Ricker, S. (2012). "Careers in High Demand." *Career Builder*. Retrieved from http://jobs.aol.com/articles/2012/11/14/stem-jobs-science-tech-careers/

Sandberg, S. (2013). *Lean In: Women, Work, and the Will to Lead*. New York, New York: Knopf Doubleday.

Sanders, J. (1995). "Girls and Technology: Villains Wanted." In Rosser, S. (Ed.), *Teaching the Majority: Breaking the Gender Barrier in Science, Mathematics, and Engineering*. New York, New York: Teachers College Press.

Schinzel, B. (2002). "Cultural Differences of Female Enrolment in Tertiary Education in Computer Science." *Proceedings of the IFIP 17th World Computer Congress – TC3 Stream on TelE-Learning: the Challenge for the Third Millennium*, Kluwer, B.V., Deventer, The Netherlands, The Netherlands, 201-208.

Schulte, C., and Knobelsdorf, M. (2007). "Attitudes towards Computer Science-Computing Experiences as a Starting Point and Barrier to Computer Science." *Proceedings of the Third International Workshop on Computing Education Research*, 27-38.

Seymour, E., and Hewitt, N. (1997). *Talking about Leaving: Why Undergraduates Leave the Sciences*. Boulder, Colorado: Westview Press.

Smith, E. (2010). "The Role of Social Supports and Self-Efficacy in College Success." *Pathways to College Network*. Retrieved from www.collegeaccess.org/images/documents/R2P/SocialSupports.pdf

Smith, L.B. (2000). "The Socialization of Females with Regard to a Technology-Related Career: Recommendation for Change." *Meridian: A Middle School Computer Technologies Journal*, 3(2), 18-46.

Steele, C.M. (1997). "A Threat in the Air: How Stereotypes Shape Intellectual Identity and Performance." *American Psychologist*, 52(6), 613.

Stephens-Davidowitz, S. (2014, January 18). "Google, Tell Me. Is My Son a Genius?" *The New York Times*. Retrieved from: http://www.nytimes.com/2014/01/19/opinion/sunday/google-tell-me-is-my-son-a-genius.html?hp&rref=opinion&_r=1

Taylor, V. (2002). "Women of Color in Computing." *ACM SIGCSE Bulletin – Women in Computing*, 34(2), 22-23.

Teague, J. (2002). "Women in Computing: What Brings Them To It, What Keeps Them In It?" *ACM SIGCSE Bulletin – Women in Computing*, 34(2), 147-158.

Townsend, G. (2002). "People Who Make a Difference: Mentors, and Role Models." *ACM SIGCSE Bulletin – Women in Computing*, 34(2), 57-61.

Trauth, E.M. (2011a). "Rethinking Gender and MIS for the Twenty-first Century." In Galliers, R. and Currie, W. (Eds.), *The Oxford Handbook on MIS*. Oxford, United Kingdom: Oxford University Press.

Trauth, E.M. (2011b). "What Can We Learn from Gender Research? Seven Lessons for Business Research Methods." *Electronic Journal of Business Research Methods*, 9(1), 1-9.

Trauth, E.M., Cain, C.C., Joshi, K.D., Kvasny, L., and Booth, K. (2012). "The Future of Gender and IT Research: Embracing Intersectionality." *Proceedings of the 50th ACM Annual Conference on Computers and People Research Conference*, 199-212.

Trauth, E.M., Huang, H., Morgan, A.J., Quesenberry, J.L., and Yeo, B.J.K. (2006). "Investigating the Existence and Value of Diversity in the Global IT Workforce: An Analytical Framework." In Niederman, F. and Ferratt, T. (Eds.), *IT Workers: Human Capital Issues in a Knowledge-based Environment*. Charlotte, North Carolina: Information Age Publishing, 331-360.

Trauth, E.M., Quesenberry, J.L., and Morgan, A.J. (2004). "Understanding the Under Representation of Women in IT: Toward a Theory of Individual Differences." *Proceedings of the 42nd ACM Annual Conference on Computers and People Research Conference*, 114-119.

Trochim, M.K. (2005). *Research Methods: The Concise Knowledge Base.* Mason, Ohio: Atomic Dog Publishing.

Turner, S.V., Brent, P.W., and Pecora, N. (2002). "Why Women Choose Information Technology Careers: Educational, Social, and Familial Influences." *Annual Educational Research Association*, New Orleans, Louisiana.

Valian, V. (1999). *Why So Slow: The Advancement of Women.* Cambridge, Massachusetts: MIT Press.

Veilleux, N., Bates, R., Jones, D., Crawford, J., and Floyd Smith, T. (2013). "The Relationship between Belonging and Ability in Computer Science." *Proceeding of the 44th ACM Technical Symposium on Computer Science Education*, 65-70.

Walton, G.M., and Cohen, G.L. (2007). "A Question of Belonging: Race, Social Fit, and Achievement." *Journal of Personality and Social Psychology*, 92(1), 82-96.

Williams, R. (1958). "Culture is Ordinary." In Gray, A. and McGuigan, J. (Eds.), *Studies in Culture: An Introductory Reader*. London, United Kingdom: Arnold, 5-14.

End Notes

1. College Board Advanced Placement Program Summary Report, 2013 (Calculus AB & BC, Computer Science A); http://www.ncwit.org/resources/numbers
2. The National Science Foundation collects data from a broad range of United States colleges and universities: http://www.nsf.gov/news/news_summ.jsp?cntn_id=127139
3. The Computer Research Association (CRA) annual Taulbee survey examines data from the Ph.D. granting universities (Research 1 (R1), e.g. Carnegie Mellon) in the United States and Canada: http://cra.org/resources/taulbee/
4. U.S. Department of Labor, Bureau of Labor Statistics, 2013 (Occupational Category: 15–0000); http://www.ncwit.org/resources/numbers
5. 1999 saw 37% women enrolled; 2000 saw 39.5% women enrolled.
6. The opinions expressed by the authors are theirs alone, and do not reflect the opinions of the Carnegie Mellon University or any employee thereof.
7. Two points of clarification: first, at Carnegie Mellon first year students are admitted directly into the CS major; and second, the School of Computer Science is home to the CS major, not the Computer Science Department as is often thought.
8. http://bits.blogs.nytimes.com/2010/02/12/barbies-next-career-computer-engineer/
9. http://www.foxnews.com/science/2013/09/05/lego-releases-first-female-scientist/
10. http://www.huffingtonpost.com/2013/08/06/the-childrens-place-shirts-girls-math_n_3714050.html
11. https://www.ncwit.org/resources/ncwit-scorecard-report-status-women-information-technology
12. http://cra.org/resources/crn-online-view/2014_taulbee_survey/
13. https://www.ncwit.org/resources/ncwit-scorecard-report-status-women-information-technology
14. http://quickfacts.census.gov/qfd/states/00000.html
15. http://quickfacts.census.gov/qfd/states/00000.html
16. http://www.nsf.gov/statistics/wmpd/2013/pdf/tab5-1.pdf
17. http://www.ncwit.org/
18. http://www.nsf.gov/od/broadeningparticipation/bp.jsp
19. ADVANCE: Increasing the Participation and Advancement of Women in Academic Science and Engineering Careers http://www.nsf.gov/funding/pgm_summ.jsp?pims_id=5383&org=CNS
20. http://www.nsf.gov/pubs/2012/nsf12584/nsf12584.htm

21. McKinsey & Company, Inc. is an international management consulting firm advising companies, government institutions and non-profit organizations on how to improve performance and meet management challenges.

22. The research had other findings relevant to this book, which we discuss later. They found that men and women were remarkably similar in professional attitudes and aspirations. The major differences were between leaders and team members not between men and women. They also found that men earned more than women and women carried most of the domestic duties. The latter was also a finding of the 2007 McKinsey & Company, Inc. report.

23. Not to be confused with the current CIT.

24. http://www.cmu.edu/about/mission.shtml

25. http://www.cmu.edu/enrollment//summerprogramsfordiversity/sams-president-stmt.html

26. President Cohon's Statement on Diversity:
http://hr.web.cmu.edu/drg/overview/statement.html

27. http://www.cmu.edu/piper/stories/2013/september/sureshwelcomesfirstclass.html

28. For a full discussion on diversity as a means or a target see Hazzan (2006).

29. http://www.cmu.edu/strategic-plan/2008-strategic-plan/2008-strategic-plan.pdf

30. Conversations with CS faculty from some universities in the United Kingdom showed that this was a well-known phenomenon. Indeed, faculty claimed to prefer students without previous backgrounds because they did not have to be re-trained.

31. CS4HS was organized by School of Computer Science faculty Tom Cortina, Lenore Blum and Carol Frieze.

32. http://www.cs.cmu.edu/cs4hs/

33. For a full account of these interventions see Blum (2001).

34. The entering class in 2006 comprised 21% women, the lowest percentage of the 2000's.

35. Quoted from the 2002 February edition of Focus, a publication of the faculty and staff of Carnegie Mellon.

36. http://www.cmu.edu/interdisciplinary/programs/bcsaprogram.html

37. http://www.women.cs.cmu.edu

38. Quoted from the 2002 February edition of Focus, a publication of the faculty and staff of Carnegie Mellon.

39. 15-211, Fundamental Data Structures and Algorithms, teaches fundamental design, analysis, and implementation of basic data structures

and algorithms, along with principles for good program design.

40. We acknowledge that Carnegie Mellon is somewhat unique in comparison to other universities. Hence, we recognize that results from our case studies may not be fully generalizable outside of the boundaries of the university. Yet, we believe that this work details examples of the many efforts to support a more balanced situation. Some examples may be replicated or effective at other institutions—others may relate less so. Furthermore, we acknowledge that our case studies use gender as the primary identity component, but do not assume women can be generalized into a single category. Rather, all people are shaped by their different identities –- albeit ethnicity, race, class, sexual orientation, family background, etc. For more information see Trauth et al., 2012.

41.
https://www.ncwit.org/sites/default/files/resources/keypracticesretainin gundergraduatescomputing_final.pdf
https://www.ncwit.org/resources/top-10-ways-retain-students-computing/top-10-ways-retain-students-computing

42. While the interview questionnaire was based on many of the questions used in the 1990's interviews, *in no way was this research meant to replicate the earlier study or the methodology involved.*

43. Although no direct question was asked about family and careers the following careers were mentioned: computer consultant, electrical engineer, programmer, computer technician, CS professor/scientist, software engineer, computer professional, mechanical engineer, CS student, computer engineer, and information sciences. Some students also referred vaguely to family members who used a computer at work.

44. "Other school" is inserted here to keep the anonymity of the actual school mentioned.

45. The term *confidence* was not used in this question.

46. Two examples of this cultural message are Orenstein (1995) and the AAUW (1991).

47. See section on *Thoughts of Switching out of the CS Major* for a full account of this area.

48. See The Confidence Code http://theconfidencecode.com/

49. The clusters are rooms which house "clusters" of computers for students to work on. The clusters are also used as classrooms.

50. "In 1989, a collection of CS graduate students and staff members at Carnegie Mellon wrote a petition, asking certain members of the program to cease leaving screen savers of nude women on their computers. While many people understood the position of the writers and made efforts to alter their behavior, others reacted poorly, calling the writers "Nazis" and refusing to succumb to their "censorship."" Quoted from

Attitudes of Women in Computer Science: 1991–1999 http://www.bluepoof.com/Colloquium/attitudes.html

51. This chapter includes summarized material from earlier publications (Frieze and Blum, 2002; Blum and Frieze, 2005a).

52. *Women@SCS* was recognized in the Gates Hillman Center Inauguration Milestones video: http://www.youtube.com/watch?v=stiFRE7Gg6g&feature=channel_page

53. Stanford's Gendered Innovations site provides many references to research on gender bias: http://genderedinnovations.stanford.edu/institutions/bias.html

54. http://www.cs.cmu.edu/~scsday/

55. We refer to the *Women@SCS* core *active members* as the Committee and/or Committee members.

56. This section summarizes content from Frieze and Blum (2002).

57. At Carnegie Mellon students enter the CS major as first year students.

58. We are reminded that the CS admissions criteria changed in 1999 to look for students who showed signs of leadership potential interpreted as those who were involved in "giving back to the community." This is certainly evident in the *Women@SCS* Committee members.

59. See http://women.cs.cmu.edu/Resources/Funding/Upstart1.php

60. These funds are no longer available.

61. Establishing a chapter of CPSR, Computing Professionals for Social Responsibility, was the idea of one of the *Women@SCS* graduate students but has since closed: http://www.cs.cmu.edu/~cpsr/

62. See http://www.techbridgeworld.org/

63. See the SCS Day website for more information: http://www.cs.cmu.edu/~scsday/

64. A full description of the Roadshow can be found in Frieze and Treat (2006).

65. http://csunplugged.org/

66. http://www.cs4fn.org/

67. A full description of the TechNights program can be found in Frieze and Treat (2006).

68. See the TechNights website for topics over the years: http://women.cs.cmu.edu/technights/

69. See http://www.cs.cmu.edu/ourcs/

70. We have presented Roadshows at WPSD and several middle school girls attend our TechNights program—all thanks especially to one great WPSD teacher.

71. This observation also serves as a reminder that admissions criteria in place by 1999 and applicable to the research cohort included look-

ing for students who showed signs of *"giving* back to the community."
Women@SCS provides many opportunities for such efforts.
72. For more information about this program see
http://women.cs.cmu.edu/What/Sisters/.
73. See the Expanding Your Horizons website at
http://www.expandingyourhorizons.org/
74.
http://nanomechanics.mit.edu/sites/default/files/documents/2011_07_J
OM_Suresh_Interview.pdf
75. The caveat here is that in some of the developing nations many
children never have access to education.
76. Indsco is a pseudonym for a real large corporation that was the site
of Kanter's study in the 1970s.
77. We recommend our readers watch "Levelling the Playing Field", a
video talk by Shelley Correll: http://gender.stanford.edu/creating-level-
playing-field; and don't miss the discussion guide with it's useful
strategies: http://gender.stanford.edu/sites/default/files/videos/
discussion-guides/CLPF_Discussion_Guide.pdf
78. http://anitaborg.org/
79. NCWIT: http://www.ncwit.org/
80. http://women.acm.org/?searchterm=ACM-W
81. http://cra-w.org/
82. http://www.nsf.gov/funding/pgm_summ.jsp?pims_id=5383
83. http://www.nsf.gov/pubs/2014/nsf14523/nsf14523.htm
84. http://www.cmd-it.org/about.html
85. http://www.washington.edu/accesscomputing/get-involved/
students/join-accesscomputing-team
86. Examples include programs run by the Math/Science Network
(including the Expanding Your Horizons Conferences), the YWCA, and
Girl Scouts of America.
87. See http://code.org/
88. Georgia Tech's Media Computation Course was set up initially as a
CS1 course to address the interests of women. More recent versions
have continued to attract a gender balanced roster.
89. See NCWIT's EngageCSEdu developed by NCWIT and Google:
www.engage-csedu.org
90. NCWIT Promising Practices: http://www.ncwit.org/sites/default/
files/resources/mediacomputationgeorgia_tech_attractingstudents
engagingintroductorycomputingcurriculum.pdf
91. http://www.scs4all.cs.cmu.edu/